MAKE ART

OR DIE TRYING

STUART SEMPLE

MAKE
ART

OR
DIE
TRYING

MAKE
ART
OR
DIE
TRYING

The only art book you'll ever need if you
want to make art that changes the world.

Illustrations by Harry George Barnes

ROCKPORT

Quarto.com

© 2024 Quarto Publishing Group USA Inc.
Text © 2024 Stuart Semple
Photography © Stuart Semple, except for:
pages 59–61, 91: Sarah Morris;
page 209: Eric Huybrechts; etc.

First published in 2024 by Rockport Publishers, an imprint of The Quarto Group,
100 Cummings Center, Suite 265-D, Beverly, MA 01915, USA.
T (978) 282-9590 F (978) 283-2742

Rockport Publishers titles are also available at discount for retail, wholesale, promotional, and bulk purchase.
For details, contact the Special Sales Manager by email at specialsales@quarto.com or by mail at
The Quarto Group, Attn: Special Sales Manager, 100 Cummings Center, Suite 265-D, Beverly, MA 01915, USA.

10 9 8 7 6 5 4 3 2 1

ISBN: 978-0-7603-8703-0

Digital edition published in 2024
eISBN: 978-0-7603-8704-7

Library of Congress Cataloging-in-Publication Data is available.

Design and Page Layout: Samantha J. Bednarek, samanthabednarek.com
Photography: Stuart Semple and Harry George Barnes unless otherwise stated
Illustrations: Harry George Barnes
Initial Design Concept: Emily Baldwin at WeAreRareDesign.co.uk

Printed in USA

MY MUM.
I LOVE YOU, I MISS YOU,
THANK YOU.

This book is dedicated to my mum. An amazing human being who sacrificed so much so I could do my thing. Her belief in me never wavered. Moo, this book is my way of passing on to others some of that belief and encouragement you had for me. You told me that normal people can change the world if they are brave enough. I love you, Moo, and I miss you so much.

What if you let me live, and I commit my life to making art?"

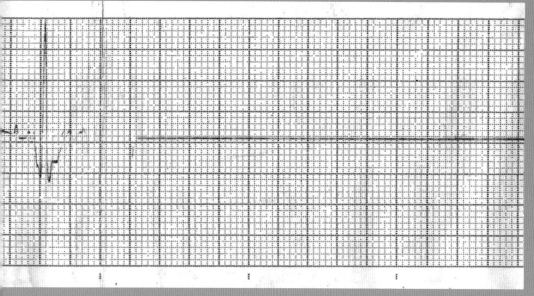

Flatline, ECG printout, 1999.

"What if you let me live, and I commit my life to making art?" my inner voice pleads with a divinity I'm not sure I believe in. Seven days in this hospital bed, a series of traumatic goodbyes to family members, and my teenage art-student body is still unprepared for what would happen next.

The bleep-bleep sound of the ECG machine flatlines to a single shrill note. It reverberates through the paper-thin, forget-me-not blue curtains between the hospital beds. The drip they fed my feeble veins with didn't stabilise the allergic reaction I'd been losing the fight against for the last few days—I was allergic to it, too, and it sent me over the edge.

There was no bright-white light. No lost family members beckoning me from the other side. Just a sense of becoming one with everything, and the most blissful, peaceful sensation I've ever felt. I was dead, but I was conscious. Aware enough to decide to come back. My eyes immediately jolted wide: I had made a promise and I intended to keep it.

I HAD MADE A PROMI
AND I INTENDED TO K

Teenage me.

ART IS FOR EVERYONE.

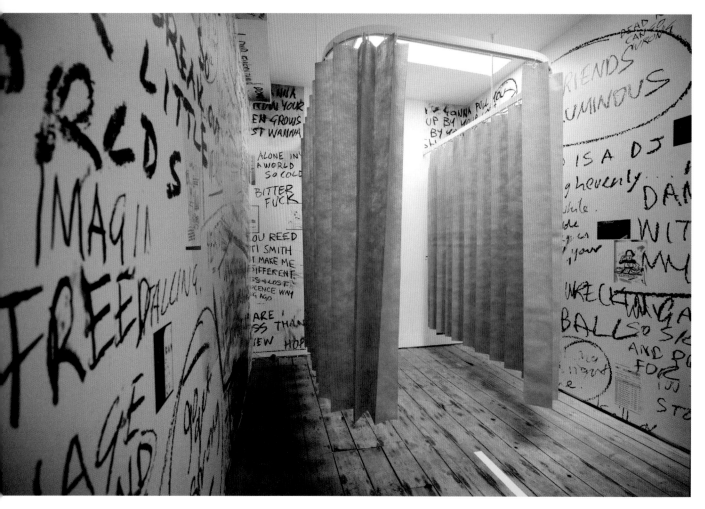

Paper Thin Privacy Curtain (installation view), Stuart Semple, Bermondsey Project Space, 2019

I WILL MAKE ART OR DIE TRYING.

That strange deal I made that night, with whatever power was there, opened up a perspective for me for the rest of my life.

That was more than twenty years ago and, since then, I've lived and breathed art every single day. I made work, travelled the world, healed anxiety, and watched the art of others transform the planet for the better.

I'm so glad to get the chance to write this book for you. It means the world to be able to share these ideas, and even more to think you might actually use them. As I write it, I'm picturing the teenage me, and I'm writing this book for him, too—the guidebook I wish I had at the start of this adventure.

I don't care where you grew up, if you've been to art school, if you have a day job, if you're in your teens or your nineties. Being an artist is possible for you right now. Everyone is an artist, every single human has a

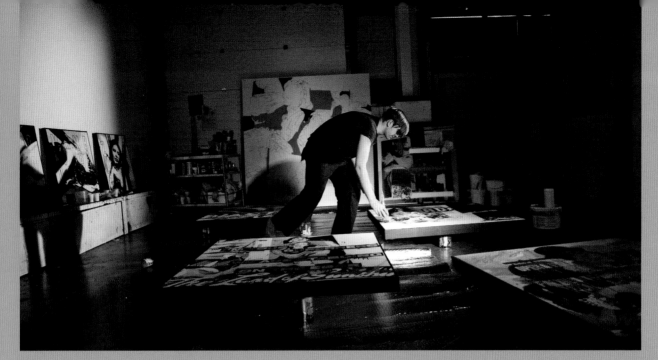

Stuart painting in his studio. Photo by Nadia Amura, 2014

spark of creativity inside them. This spark can and will make the world a better place when others come in contact with it. I've seen art change people, places, attitudes, and communities. I've seen it heal, and I've seen it communicate where words aren't enough. I must tell you that living as an artist is a gift. It's as close to freedom as you could wish for, but it takes commitment and dedication. Please don't think you are going to buy this book, read it, and suddenly fall into making work that really matters and resonates. This book should, hopefully, point you in the right direction of finding your voice in the crowd, getting it heard above the masses, and connecting with audiences in profound ways, but the rest is up to you.

We are in a time where we really need our business leaders, politicians, and educators to think like artists because that's the only way they will innovate enough to create the future we all deserve. Hopefully, some of them will read this, too. But until they start getting it, artists just like you might need to take the lead in daydreaming for all of us.

TOOLING YOU UP.

If you're going to make the impact we want, you will need to be equipped with some tools—the biggest one being the work of all the amazing artists before

you. They've done the work and kicked at the edges of the circle until the middle moved. You can easily stand on the shoulders of these giants, and the good news is, even though it might feel like you are starting at square one, you're not. You've arrived thousands of years into this.

We will look at some of these artists' big arty ideas together. I won't be able to go into everything, of course, but I will share the ideas that have inspired me the most, in the hope they'll inspire you, too.

I'll share some of my work and some of the scrapes I've got through making it. Then, at the end of each chapter, I'll take you through a few exercises where you get to make your own work and, ultimately, develop your unique conversation with the wider world. I've made a load of videos to go along with this, too, so you can just scan the QR code at the end of each chapter to join me online to take this way deeper.

So, if you're ready to dive in, let's look at the ideas of these artistic giants and see how you can start to build upon them in your own life.

Onward!

IDEAS

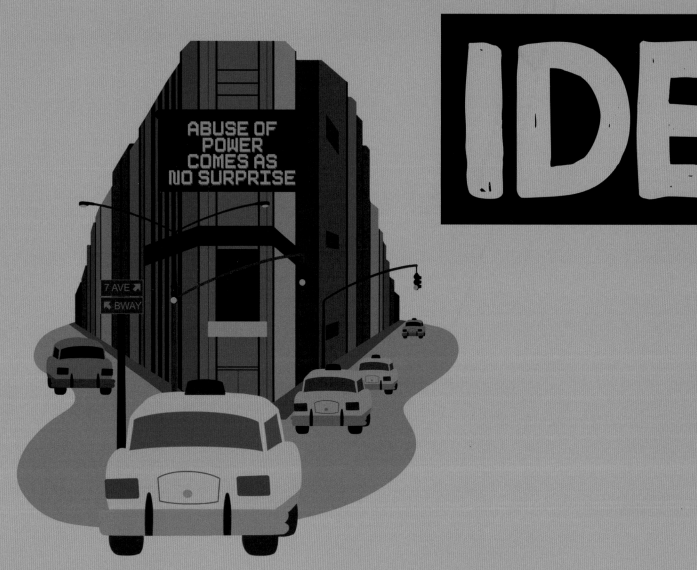

The big idea was to cha
traditional ways that
made. To shake the esta
felt exclusive, domin
emies and gatekeeper
what was and what wa
the illustriou

AS
IDEAS

ings crack and fade with
ventually even marble can
ble, but ideas are things that
ast forever because they were
things in the first place.

IDEAS IDEAS

IDEAS

AND HOW TO HAVE THEM.

Okay, so we're going to explore conceptual art together. If you already know all about it, put your knowledge to one side and revisit this as a beginner. If you're completely new here, there's nothing to be scared of. Before we delve in, please know there is no way I can get into the nuance and depth of it in one little chapter—I could go on for volumes. That doesn't matter! Actually, it's better. We can hone in on the essence of it and, if it rocks your boat, there's a whole world to uncover.

IDEAS

To go forward, we need to start by going back. Let's take a trip to June 1961, where we find Henry Flynt (American, born 1940) writing about what he called "concept art." This is a brilliant moment to be alive, the avant-garde art scene in New York is buzzing and Flynt's essay talks, for the first time, about the concept of something being art in its own right. He explains that music is sound, and art is ideas. He might have denied he was a conceptual artist because his art was all about language and how it describes things. There's no doubt in my mind, however, that his thoughts solidified what was in the air at the time and acted as, at the very least, a barometer for the idea that art no longer needed to be a "thing."

DAYDREAMING IS FREE.

The big idea was to challenge all the traditional ways that art was being made. To shake the establishment that felt exclusive, dominated by academies and gatekeepers who decided what was and what wasn't allowed in the illustrious canon of art. Imagine making art that couldn't be bought or sold, something that existed outside the system.

Nobody did it better than Lee Lozano (American, 1930–1999), who started her *General Strike Piece* in 1969, declaring her resignation from the art world and documenting her final visits to galleries and museums. Artists: 1; artworld power structures and commercial concerns: 0!

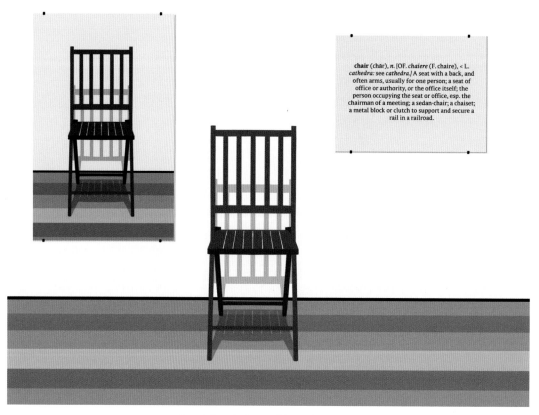

Joseph Kosuth, *One and Three Chairs*, 1965

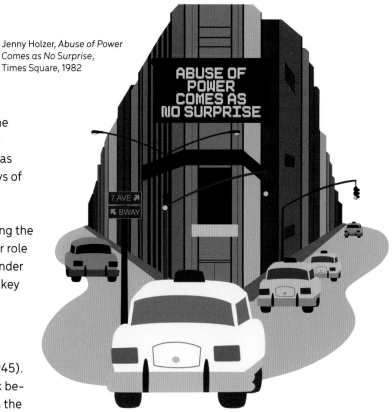

Here, ideas and concepts reigned supreme, and the finished object and what it looked like were firmly relegated to the bench. Using traditional media was old school; new, innovative, and experimental ways of doing things were in, in a big way.

Coming off the back of Dada and Surrealism, during the 1910s and '20s, these artists understood that their role was to provoke. That art itself should be thrown under the bus and challenged. Let's look at some of the key artists and artworks that defined the scene.

WORDS THAT DESCRIBE THINGS.

Let's start with Joseph Kosuth (American, born 1945). Like Henry Flynt, he was very interested in the link between language and art—how we describe things, the very words we use and the meaning they have. I can ask you to picture something red, and the word, no doubt, shows up as something in your mind. We have no way of knowing if your image of red and my image of red are the same thing. The word is a handy way for us to get on the same page—it kind of replaces the need for us to have the same experience. This could be a bit far out but, maybe, just maybe, there is no ultimate red at all.

Kosuth's most famous work is his series of *One and Three* installations. He shows us three versions of a chair: a photo, the dictionary definition, and an actual physical chair. Just as I explained with red, he's questioning the idea of a chair. Ultimately, the big idea is that the way we describe things changes our experience of the world.

Let's chat now about Sol LeWitt (American, 1928–2007), another of the big 1960s heavy hitters. He's best known for his wall drawings—large-scale, geometric compositions that were made by assistants according to a set of written instructions he gave them. LeWitt's work was all about the idea behind the artwork, too. He was less interested in the finished product, as he explained in his 1967 essay "Paragraphs on Conceptual Art"—"The idea itself, even if not made visual, is as much a work of art as any finished product."

By the 1980s, and beyond, conceptual art had expanded massively and had become so established it was almost uncool and a bit ignorant *not* to be conceptual. One of the most important figures of this era was Jenny Holzer (American, born 1950), who used LED displays to display text-based work in public spaces. Her *Truisms* series consists of short, provocative statements, such as "Abuse of power comes as no surprise," which pushed viewers to face uncomfortable truths about society and politics.

Y, THE BIG IDEA IS THAT THE ESCRIBE THINGS CHANGES RIENCE OF THE WORLD.

THE GAMES ARTISTS PLAY.

I really love John Baldessari (American, 1931–2020). If I'm totally honest, I have a bit of an artist crush on him. He's made work I keep coming back to time and again. I want to make sure it's on your radar because it might just inspire you as much as it inspired me. He loved the idea of games, and what he liked about games was that they almost always have some kind of arbitrary goal and a set of rules. So, he would make things where he would show his attempts to win. One of my faves is his 1973 piece *Throwing Three Balls in the Air to Get a Straight Line*. It's, basically, what it says on the tin, meaning, it is what it's called. He photographed his trials and presented the best of thirty-six tries. He chose thirty-six because that's how many shots he had on a roll of close up film. It's totally brilliant.

Let's come a little bit closer to the present day and hone in on another one of my favourite pieces of work ever. Martin Creed's (British, born 1968) *Work No. 227: The lights going on and off*. Madonna handed him the Turner Prize for it in 2000, whilst the global media and the general public scratched their heads. Creed's piece was nothing short of genius. The work itself is simply a set of instructions saying that the gallery would have the lights on for five seconds, then off for five seconds, and this would be repeated forever. Such a simple act completely transformed the museum, by adding nothing physical, or taking anything physical away. This, to me, is about as close to the perfect piece of conceptual art you can ever get. It's provocative, transformational, and fuelled entirely by an idea.

John Baldessari, *Throwing Three Balls in the Air to Get a Straight Line (Best of Thirty-Six Attempts)*, 1973

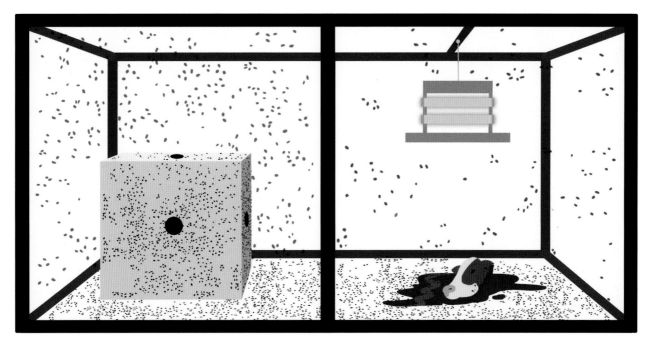

Damien Hirst, *A Thousand Years*, 1990

HEAVENLY ZAPPERS.

Of course, we can't talk about conceptual art without touching on the original "bad boy" of British art, Damien Hirst (British, born 1965). We can talk about Hirst for days, but the point is, he's an ideas man. He'd tell you he started off with his best idea, and that was a glass box with a decomposing cow's head in one side, a box with maggots in the other, and an electronic fly zapper hanging above. The maggots fed on the cow's head, they turned into flies, and the flies got electro-cuted by the zapper. Now, it's gritty, and as a vegan, it weirds me out, but to encapsulate a whole lifecycle in a living piece of work was brilliant. Nobody had ever presented anything like that before. Yes, it's gruesome and a bit macabre, but it's impossible to view the work without reflecting deeply on our own mortality: Why we are here? And, ultimately, how long have we got left before the big zapper in the sky takes us, too?

Why we are here? And, ultim... how long have we got left bef... big zapper in the sky takes u...

MY BRIGHT IDEAS

MY BRIGHT IDEAS

was all it... it would have done a dis the idea that it could ex imagination of others.

A 30 FEET HIGH PORCELAIN PIG, PAINTED PINK AND INSTALLED IN CENTRAL PARK.

Stuart Semple, *A Pink Pig*, 2001

After I nearly died, I found myself back at my parents' house, having to put the art degree on hold. Whilst I was painting my experience compulsively, I was also very involved in daydreaming works I couldn't possibly realise. I didn't know it at the time, but these unrealised works would be some of the first conceptual things I would make. I fell into making text-based work, where I would use words to describe sculptures that were impossible to create. I told you before, daydreaming is free. One of the first ones was a "30 feet high porcelain pig, painted pink and installed in Central Park." It felt so liberating to write down those words. Knowing that the idea was all it required, actually making it would have done a disservice to the idea that it could exist only in the imagination of others. This lead me to using text in most of my work, as a way to use language to stir an idea of something in the viewer that I didn't need to make. I often have a series of these "cerebral sculptures," as I call them, up my sleeve, and I'll often give one to someone I meet, a sculpture that lives only in their mind.

NOTHING AT ALL COULD BE SO MUCH FUN.

I wanted to find a way to show absolutely nothing. To have no art at all, just a very deep, direct experience of being with yourself.

As part of my recovery, I became fascinated with different religions and spirituality. I knew that even when I died, I seemed to stay aware. That my body died and my mind died but awareness didn't. Every day I'd go to the local bookshop and spend hours reading. The spirituality section lit me up, as ancient sages and monks described mystical experiences that seemed a bit similar to what had happened to me.

I wanted to find a way to point towards that experience in my work. So, I built a cube in a woodland. I painted the inside with the blackest paint in the world (more about the blackest black later). This cube was entirely soundproofed, and I programmed it so that light emitted from it as you approached, but when you went inside, the light would fade and a voice explained that you should sit there until a bell sounded and then you could leave. In the pitch-black infinite dark, with no light, and no sound, experience itself seemed to be very loud. All the visitor was left with was their mind and the passing of ideas. Their mind was the art.

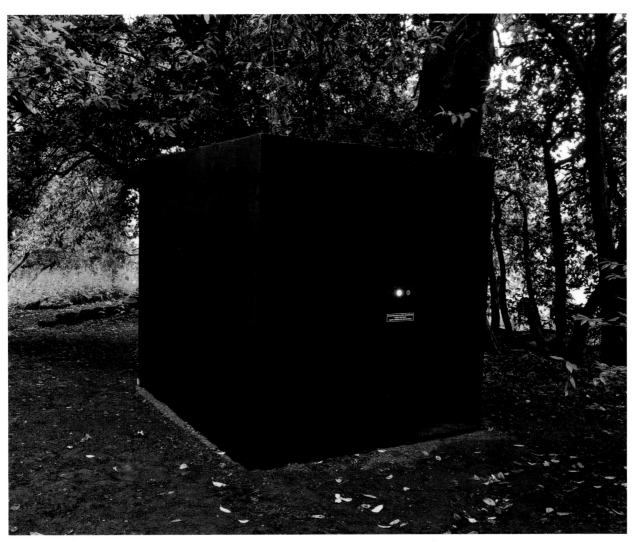

Stuart Semple, *Absolutely Nothing*, 2018

MY BRIGHT IDEAS

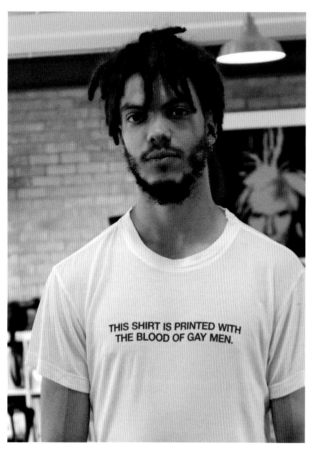

Liam wears "Gay Blood" T-shirt.

GAY BLOOD

In this example, I wanted to make a statement about a law I thought was stupid. In the United States, gay men weren't allowed to donate blood. Even though all blood is tested for diseases, the US Food and Drug Administration was still screening blood with stigma rather than science. I thought it ridiculous that the majority of other countries around the world had dropped the idiocy decades ago, and in light of a severe shortage of blood, and thousands and thousands of gay men desperate to donate, I wanted to make some work about it. So, I teamed up with my friends at Mother (a creative agency) in New York, who got several of their gay male employees to donate blood. I took that blood and created a screenprint ink that was used on T-shirts. Then, I continued to create a whole series of art materials based on the "gay blood" that anyone could use to express their disdain for the law. I'm pleased to see that law has now been changed. I'll never know if the work played a part in that. It wasn't about the T-shirt or the Gay Blood paint, it was about the idea behind those things, what they stood for, and what they meant. That, to me, is what makes them conceptual art objects, not merely products or clothes.

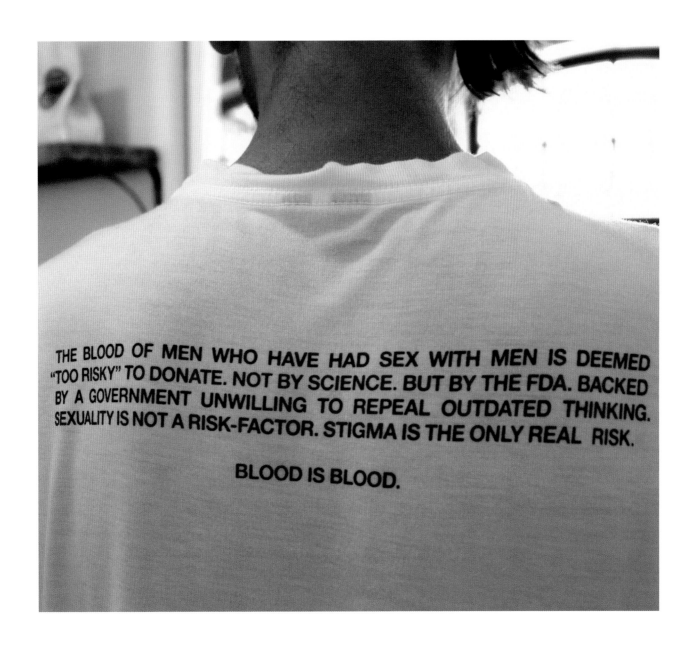

THE BLOOD OF MEN WHO HAVE HAD SEX WITH MEN IS DEEMED "TOO RISKY" TO DONATE. NOT BY SCIENCE. BUT BY THE FDA. BACKED BY A GOVERNMENT UNWILLING TO REPEAL OUTDATED THINKING. SEXUALITY IS NOT A RISK-FACTOR. STIGMA IS THE ONLY REAL RISK.

BLOOD IS BLOOD.

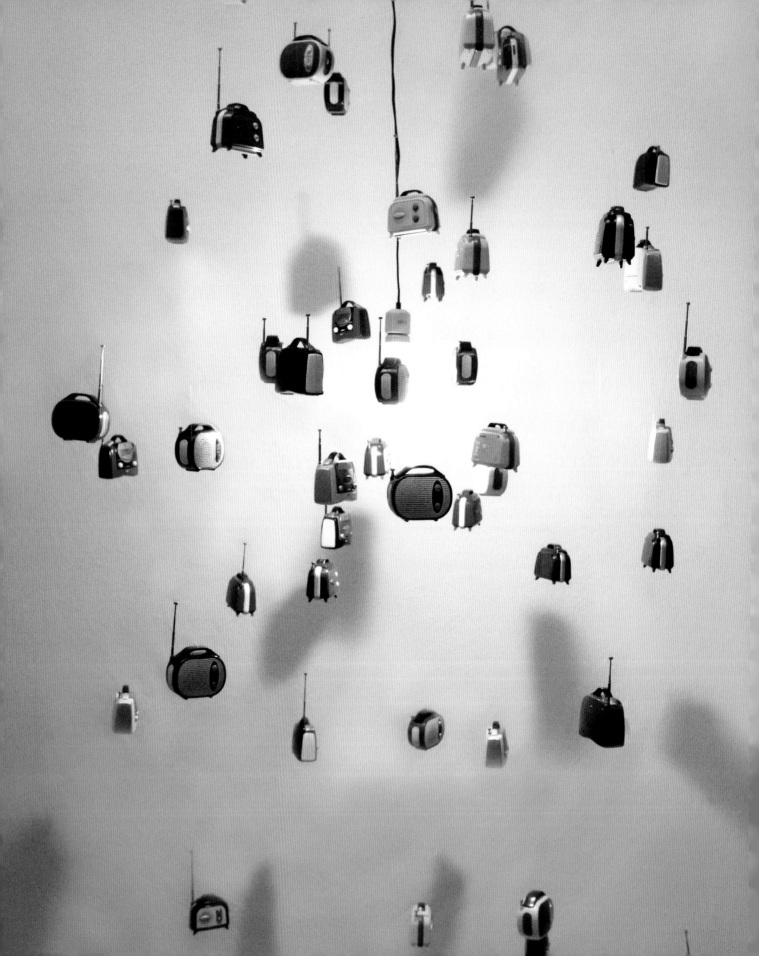

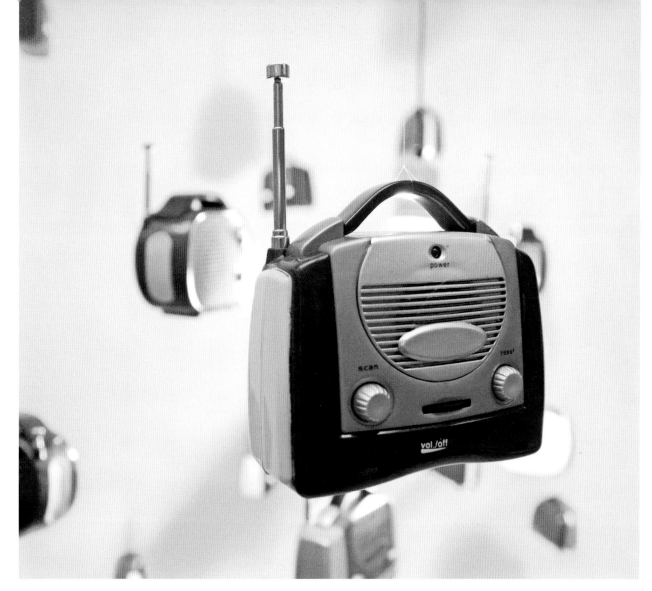

Stuart Semple, *OMEGA, Radios, Fishing Tackle, and Lightbulb*, 2013

THE SOUND OF THE END OF TIME.

I'm a massive fan of Bob Dylan (American, born 1941). A lot of his lyrics conjure ideas for works and often feature in the things I get up to creatively. On this occasion, I was in the car and Bob's voice sang "the last radio playing." There's something really haunting about the idea of an obliterated planet with one last radio playing something. I thought nothing more about it, but the next day on the radio there was a programme all about the Big Bang, and how, in the white noise between radio stations, there is a small percentage of leftover reverberations from the start of time. That's an amazing concept, and I wanted to make something out of it. Remembering my Catholic upbringing and the Bible, I knew that creation was the Alpha and the Omega, the beginning and the end. It wasn't a huge leap to work out that the end of time might well sound like the beginning of it. So, I got my hands on hundreds of tiny little radios, tuned them all into the white noise between stations, and suspended them as a cluster. Gallery visitors could then, perhaps, experience the sound of the end of the world.

YOUR IDEAS

Okay, now it's time for our first set of creative exercises together. As we make our way through the book, these will build to give you a series of experiments that might be all you need to start making a major impact with your ideas.

Paintings crack and fade with age, eventually even marble can crumble, but ideas are things that can last forever because they were never things in the first place.

You don't need to know "how" you are going to make things. You don't need any money or any other resources. As I said at the start, daydreaming is free.

TAKE THE VOW.

Before we start, I ask you to take a solemn pledge, a vow, if you like. As uncomfortable and weird as this sounds, I'd like you to find a mirror, look yourself firmly in the eye, and declare:

> I, [your name], solemnly swear to abandon all I know about making things look good, everything I believe about what is or is not art. I promise to cast aside all I've learned about composition, form, flourishes, and finesse. I know I can pick that back up later. For now, I will focus on ideas and ideas alone. How they take form is not my business.

CAPTURE YOUR IDEAS.

To being, I need you to know that ideas are fleeting. I like to think they are floating around in the ether, waiting for someone receptive to give them a runway to land on. You need to be that runway. The greatest artists of all time have all spoken about work they made, that they had almost nothing to do with, stuff that just kind of happened. This is actually the original idea of a muse. Pablo Picasso (Spanish, 1881–1973), Jean-Michel Basquiat (American, 1960–1988), and even Bob Dylan had a relationship with that muse, with Dylan believing the muse gave up on him after his first couple of albums. Anyway, you need to start a practice of capturing these ideas. The more you do it, the more they will land; and the more you can act on them, the better their quality and the more powerful they will be.

I know, I know—it sounds like total woo-woo, but just humour me.

I need you to decide on your ideal ideas-capturing device. I have a huge blackboard in my studio, a notes app on my phone, and a notebook in my bag. I just want to be ready should an idea strike. What will your tools be? A voice note app? Emailing yourself? A notebook?

Decide on your capture device now. And promise yourself you'll have it with you until we've finished working together throughout this book.

Hatch your ideas. Find a few sheets of paper or a notebook and a pen or pencil. Please—no laptops, tablets, or phones. I want this to be physical.

don't need to know
v" you are going to
ke things. You don't
d any money or any

IDEA MACHINES.

If the idea is the machine makes the work, let's start by making some machines.

Set an alarm for ten minutes. Your job is to write down ideas for as many artworks as you possibly can in that time.

- A cardboard box full of kittens attached to a hot air balloon
- A group of trees planted to form the shape of an alien when viewed from space
- A painting of concentric circles each in a contrasting colour to the circle before
- Etc...

You get the idea—now it's your turn. And my best tip here: Do your best to be deliberately un-artful. Be with the idea, and keep your head away from what the outcome *looks* like. The minute you start thinking about the craft of making something, you've gone too far.

Perhaps document a piece of fruit as it decomposes.

YOUR IDEAS ARE ART. LET'S SHARE THEM.

Well done. Hopefully, you've got a heap of ideas. It doesn't matter how ridiculous they may be. Don't judge them. They never need to be made. The good news is, each one is already art, even without being clothed in any more than your handwriting.

Let's actually get some of them out, though, shall we? Let's think about ways to share them with the world. Are you going to type up an idea and print it out and take a photo of it for social media? Or will you simply call someone and describe it to them in conversation? Will you write one on a little card and leave it somewhere? Will you write it in chalk on the sidewalk?

If you actually did that, you did something massive. You shared a piece of conceptual art with the world. You really are an artist.

YOUR IDEAS

Take a photo of the same thing every day.

SAVING IDEAS IN THE REAL WORLD.

All that's left of so many brilliant conceptual works is the documentation. The photos, videos, and descriptions. I want you to start documenting what you do, too. There's a big history of that in conceptual art. Just as Baldessari photographed his attempts to throw balls in a line, what will you document?

- Take one photo a day for the next thirty-six days. I've picked thirty-six in homage to the artists who came before us, who only had thirty-six shots on a roll of film. You, however, can just use your phone.
- You could photograph a helium balloon deflating every day, or an apple rotting. Maybe you could even photograph your own body. What are you interested in? What can you do?
- Pick something and take photos of it daily.

THE THING IS RARELY EVER THE THING.

Finally, I want to end this chapter by giving you a very direct experience. You remember the three chairs I showed you before by Kosuth. Sadly, I can't transport you to a museum to experience it, but I can connect you with the idea, right here, right now, in your own home. Remember, ideas are immortal, and they aren't stored in the art; we can access them from anywhere.

YOUR VERY OWN ONE AND THREE.

- Grab a piece of paper, your phone, and any household object you like. Put the object in front of you, maybe on the floor or on the side of the kitchen counter.
- Look up the dictionary definition of the object you chose. Let's say you picked a plant pot. Write the dictionary definition of the plant pot on a piece of paper using your pen.
- Now, take a photo of the plant pot (or whatever object you chose) with your phone.
- You now have three things: 1) an image on your phone, 2) the original object, and 3) the dictionary definition of the object. Lay them out next to each other.

MY GOSH, WHAT HAVE YOU DONE?

- Ask yourself, "Where is the art?"
- What in front of me signifies the original object?
- Have I changed the object into something else?

Once you've had a good old think about what's in front of you, put it all away. Delete the photo from your phone and see whether, even though it's gone in one sense, the art lives on in the idea, in your memory.

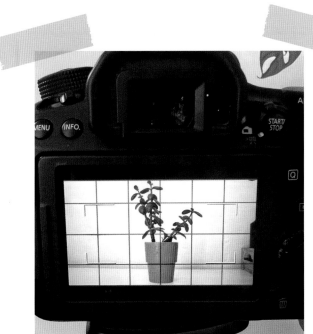

Take a photo of a household object.

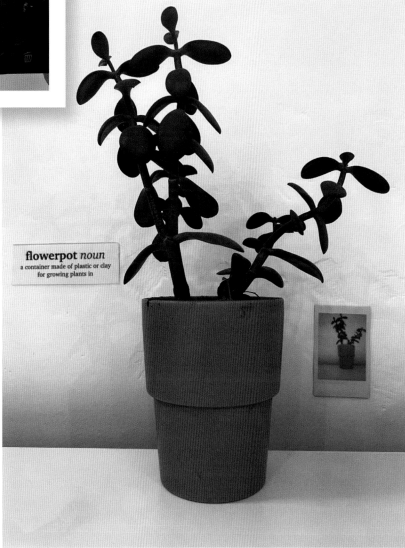

flowerpot *noun*
a container made of plastic or clay
for growing plants in

Put the object next to the dictionary
definition and the photo.

SCAN TO VIEW AN
EXCLUSIVE VIDEO
FROM STUART!

MOVE

MOVE IT

Could it be that the simp
act of moving something
one place to another com
transforms what it mean

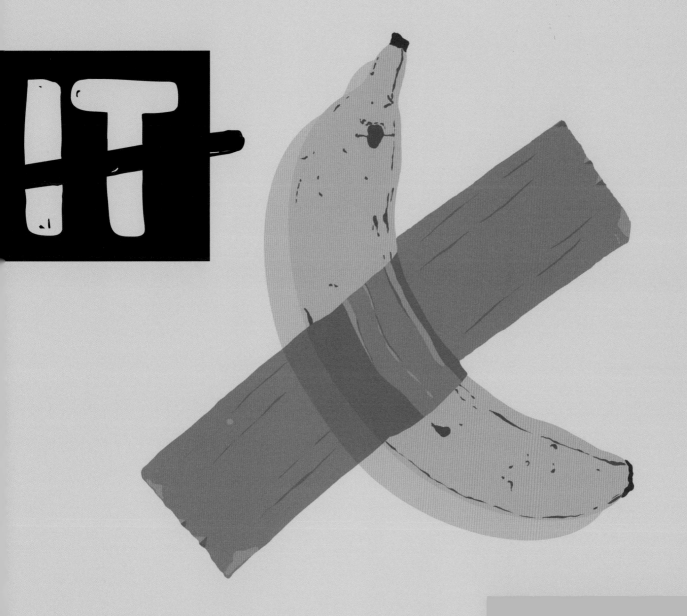

IT

st way to think about it is
rtists can represent things
a photo of something, or paint
sion of it, for example

MOVE IT

MO
VE IT

MOVE IT
MOVE IT
MOVE IT
MOVE IT
MOVE IT

**MOVING THINGS ABOUT—
ESPECIALLY NON-ART THINGS.**

Welcome to the world of the readymade, a phantom zone where everyday objects morph into works of art just because we declare them to be. Could it be that the simple act of moving something from one place to another completely transforms what it means? Can we finally lay to rest the age-old "But is it art?" argument? Let's get moving and find out.

MOVE IT
MOVE IT
MOVE IT

MOVE-MENT

"It's a pile of bricks." "It's a messy bed." "It's a flipping toilet!" scream the tabloids when faced with another object from the real world, thrust under the gaze of the public by presenting it in a major museum. Shortly after that, variations of "It's not art" or "I could have done that" erupt from every person and his dog. Something about it seems too easy. That an artist should receive that acclaim for simply showing what already exists feels like a bit of a rip-off. There's no skill, craft, or originality. Surely, it can't be art! But it is, it really is, and it's some of the best, most inspiring work ever made. So, what is it that I see that some people don't?

I'm going to lay my cards firmly on the table here, take it or leave it—I have zero interest in debating whether something is art or not. In fact, of all the conversations we could have about art and ideas, that one's probably the one with the biggest red flag warning of a dead-end. As far as I'm concerned, if you say it's art, then it's art. Let's move on. The point is this: Most people see art as a very black-or-white, binary thing. At one end of the spectrum, we have real life and all its objects, and at the other, we have art. Art is allowed to *represent* real life, like a painting of a landscape, or a photo of something. However, art is not allowed to *be* the thing itself. You can't just go around grabbing the actual thing and shoving it in a gallery and calling it art. Well, actually—yes, you can.

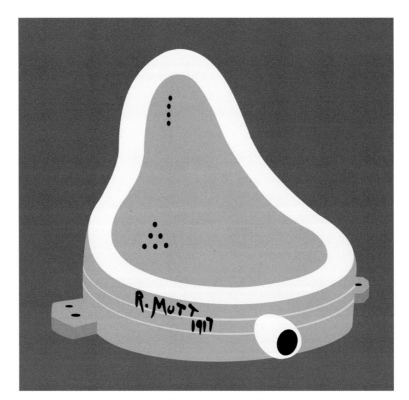

Marcel Duchamp, *Fountain*, 1917

And artists like you were given a blank p

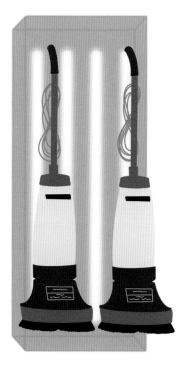

Jeff Koons, *New Hoover Quick Broom, New Hoover Celebrity IV*, 1980, and *New Hoover Deluxe Shampoo Polishers*, 1980

The best way to think about it is that artists can *represent* things—take a photo of something, or paint a version of it, for example. A bit like we saw in the last chapter with the photograph of the chair. A kind of copy that reminds us of the real thing. Or artists can harness the readymade and actually *present* the original thing itself. In this case, an actual chair.

Let's take a quick look at some examples so you can get a sense of what I'm on about and, hopefully, a few ideas for your own stuff, too.

ONE URINAL TO RULE THEM ALL

Picture this: a urinal in an art gallery. Sounds absurd, right? But that's exactly what happened when Marcel Duchamp (French, 1887–1968) unveiled his ground-breaking work, *Fountain*, way back in 1917. Suddenly, an everyday object was transformed into art simply by changing its context. He moved something from one place to another, turned it on its side, and signed it "R. Mutt." He turned the art world on its axis, too. He was the first to put a mass-produced object on show, and something as crass as a toilet at that. His point was that anything—good, bad, or ugly—could be art

if an artist said it was. Thus, the readymade was born. And artists like you and me were given a blank permission slip to go use whatever we could get our hands on. This punk-ass gesture by Duchamp shunned the very notion of art having to be original and opened up the world to just about anything.

But Duchamp wasn't the only one to play this game. In the eighties, Jeff Koons (American, born 1955) famously took basketballs and vacuum cleaners, objects you'd find in your neighbour's garage, and presented them as high art. For Koons, this series, which he called *The New*, presented vacuum cleaners in Perspex (acrylic) boxes and laid them out in a kind of anthropomorphic way, in that they kind of developed a personality. They became strangely human in the gallery. He'd group them together to feel like family units, or lay them flat as if they were in a coffin. He used fluorescent lights with them, too, which gave them a clinical, sterile, fresh new look. Just what is it that makes a simple vacuum cleaner so appealing?

BANANA-SHAPED RIPPLES.

More recently, one of my favourite artists, Maurizio Cattelan (Italian, born 1960), stuck a banana on the wall of an art fair with gaffer's tape, gave it the title *Comedian*, and a price tag of $100,000 (£80,500). In our social media age, parodies and memes of the banana spread like viral wildfire, but what Cattelan is up to is way better than merely a cheap joke. The piece challenged the very idea of an art fair, a place people go to trade art as commodities, and he slapped a perishable work—a banana—on a wall. It is very, very funny. Cattelan is a wickedly naughty artist with a massive sense of humour. The mainstream media totally slipped on his banana skin and ended up falling into the "emperor's new clothes" storyline he was trying to provoke. Never in recent history has something so simple caused such a commotion. It shows perfectly how good artists can provoke and how they challenge the establishment. This non-art object became a massive artistic gesture through the ripples it stirred.

In fact, the humour of readymades lies precisely in their ability to provoke laughter whilst challenging our preconceptions. Back to Damien Hirst and a hilarious moment where a cleaner, in the mix-up, mistook one of his installations for mere rubbish and attempted to dispose of it. Talk about an awkward encounter! Seems like one person's art could literally be another person's rubbish.

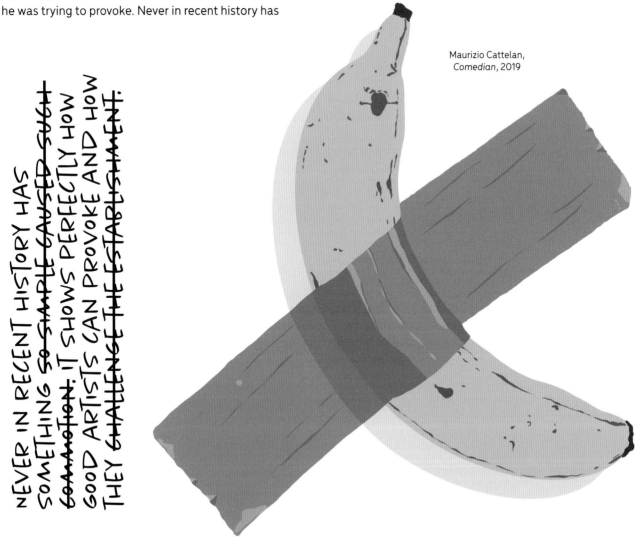

Maurizio Cattelan,
Comedian, 2019

NEVER IN RECENT HISTORY HAS SOMETHING SO SIMPLE CAUSED SUCH COMMOTION. IT SHOWS PERFECTLY HOW GOOD ARTISTS CAN PROVOKE AND HOW THEY CHALLENGE THE ESTABLISHMENT.

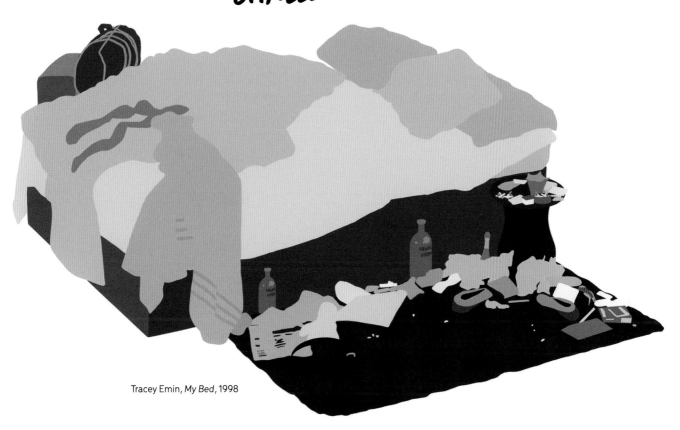

Tracey Emin, *My Bed*, 1998

IN BED WITH TRACEY.

One of the most impactful readymade works I've ever seen was Tracey Emin's (English, born 1963) 1998 work simply titled *My Bed*. This piece was largely misunderstood by the mainstream, but, to me, seeing it in real life as a teenager hit me hard. It was so intimate, tender, and honest. After a series of really tragic life events, a depressed Tracey ended up in bed. She didn't leave for days, eating nothing and only drinking alcohol. The desperation and lack of will to do anything are conveyed so brilliantly by the mess surrounding the bed. Packets of cigarettes, empty bottles, and underwear were strewn around. It's rare for a readymade to feel so personal and have such a narrative imbued in it. I see it more as a self-portrait of Tracey at a specific moment in time. It's a brilliant and brave artwork that Tracey didn't even realise she'd made until afterwards.

STUFF I'VE ~~MOVED~~

STUFF I'VE MOVED

I'm swirling ideas in my head and look ways to get them out, very now and then, the around me suddenly to make sense.

There have been a few points in my life where utilising the readymade has made sense in my work. Often, I'm swirling ideas around in my head and looking for ways to get them out, and, every now and then, the things around me suddenly seem to make sense.

I seem to get my best ideas in the bath, late at night. On one of those occasions, I had an exhibition looming in Hong Kong, I knew I wanted to make some work that spoke about the bullying I experienced growing up. Those futile, flimsy words that kids throw around that seem soft but, on the receiving end, can feel like they sting and maybe even cause long-term damage. Stupid words like "freak" or "wuss" or "loser." Anyway, I'm in the bath and there are all these little foam letters that, when they get wet, can stick to the tiles. They belonged to my two-year-old son. I started sticking them to the tiles trying out pathetic insults when I realised I could slot them together to make sculptural forms. These

EUREKA! I HAD IT, THE WORK FOR THE SHOW, A SERIES OF FOAM LETTER FORMS, SLOTTED TOGETHER SO THEY COULD BARELY SUPPORT THEMSELVES.

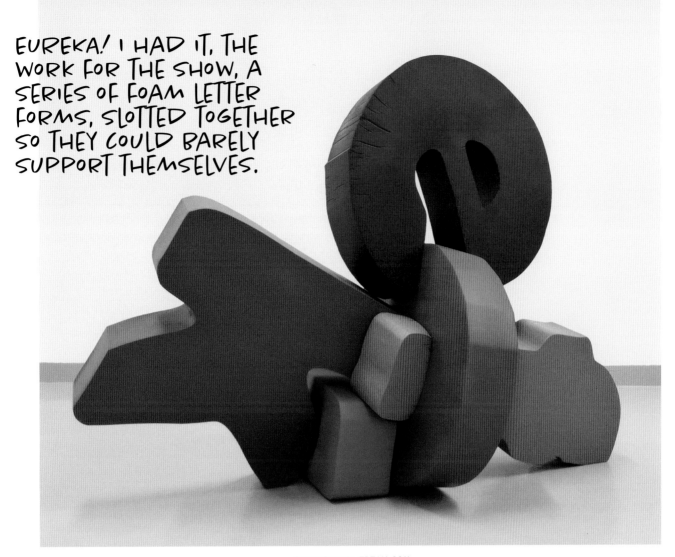

Stuart Semple, *FREAK*, 2011

forms were weak, almost incapable of supporting themselves. EUREKA! I had it, the work for the show, a series of foam letter forms, slotted together so they could barely support themselves. I took the foam letters out of the bath, scaled them up, and popped them in a gallery—job done!

ART MAKES LIFE.

One morning I got a call from the Fertility Partnership; they work on helping women donate their eggs so those who aren't able to have a child can! A beautiful thing, but the voice down the end of the phone was worried: There was a problem. Women in the United

Kingdom didn't really understand what it meant to give the gift of life to another woman and were confused about donation. They wanted to pick my brain to see if art could help.

I realised that balloons could, in the right context, look a little bit like eggs. My idea was to shift the usual environment in which you find balloons and install them at the crack of dawn all over the United Kingdom so, as the world woke up, it would be greeted by these seemingly impromptu sculptures.

STUFF I'VE MOVED

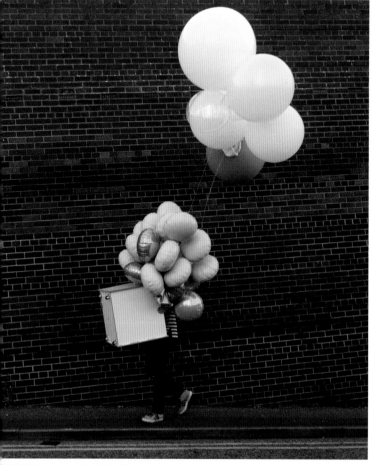

I set about inflating hundreds of these giant pastel-coloured balloons in a gymnasium that then got loaded onto vans, driven overnight, and installed in seven cities throughout the United Kingdom. The balloons became art because they were so out of place. They presented an opportunity to meet women and hand out information about egg donation. I gave those I met a little signed balloon of their own, rare and, potentially, even with value. I explained that passing it on to a stranger would magnify its power. The idea is that giving an egg could change someone's life.

A year or so later, the phone rang again—the same lady from the Fertility Partnership. I couldn't believe what I heard. Two babies were born from eggs donated by women who saw one of those readymade balloon sculptures. I can't begin to get my head around the idea that art could have that much of an impact. The point here is that when we take something as simple as a balloon and change its meaning, wonderful things might happen.

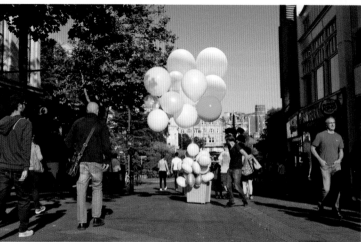

Stuart Semple, *Something Amazing*,
balloon intervention, 2016

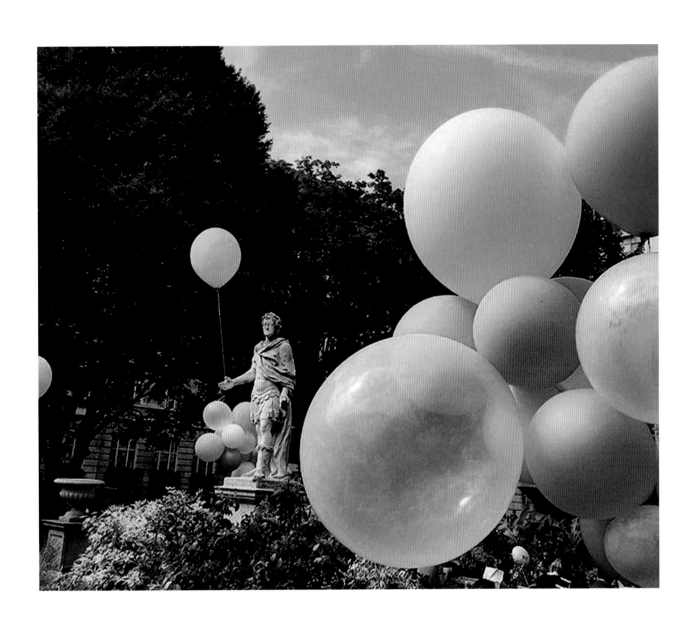

**I SHOULD BE CRYING, BUT I JUST
CAN'T LET IT SHOW.**

The alleyways in Denver are problematic. Just off the
16th Street Mall there are no-go areas, often beacons
for antisocial behaviour and crime. So, really, they
are just the type of place that moving art into could
make a real impact. In my studio, I started playing
with plasticine, imagining what I would make in that
alleyway if I could make anything. I know people there
are going through tough times, and I wanted to speak
about that quiet resolve we have to keep going, and
force a smile under pressure, even when it feels like the
world is squishing us from every side. I quickly came
up with a squashed smiley head, and realised that
happiness, really, is an inside job. It's a state of mind
and, perhaps, it's wrong to hand it over to the outside
world. We scaled the piece up to be a whopping fifteen
feet (4.5 metres) tall, made of steel and foam, and we
squished it in the alleyway. By moving the head and
putting the right thing in the wrong place, I hope it
changed the alleyway for everyone who saw it.

That's enough of my stuff. Let's get ready to make
some work together. If you're ready, let's move on and
get busy moving things around in your world, to make
them just that little bit more interesting.

Stuart Semple, *I Should Be Crying But I Just Can't Let it Show*, 2018

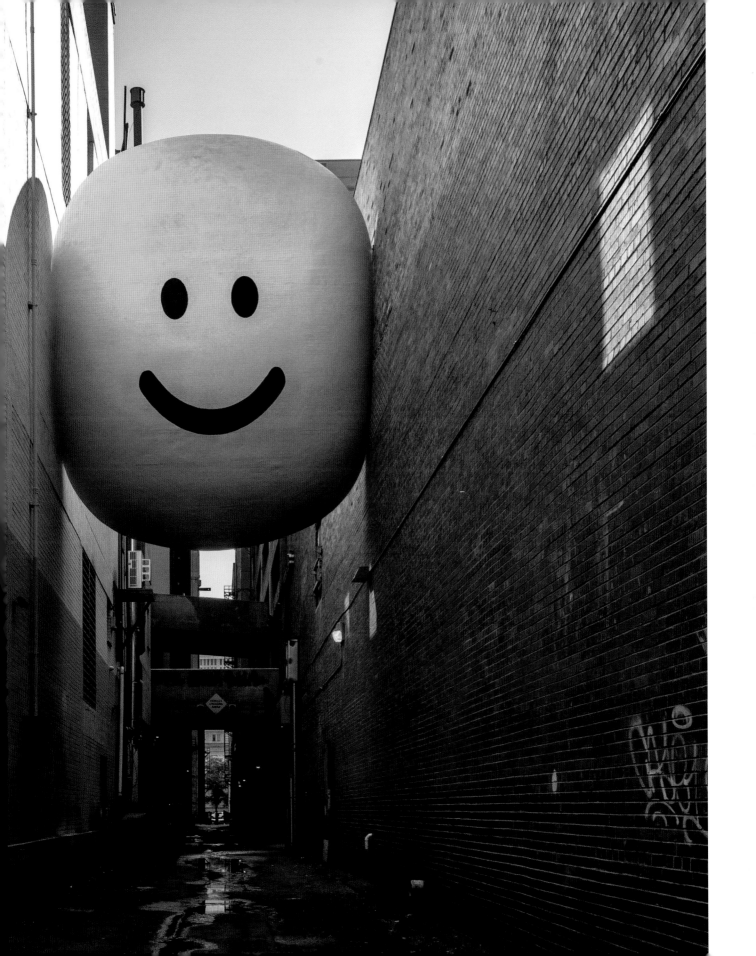

YOUR TURN TO MOVE

Hopefully, you're feeling nicely inspired with a sense of freedom about what's possible. Using existing objects to harness your ideas is a powerful way of working.

Building upon the work you did in the previous chapter, let's take it all a stage further by applying those ideas to some readymades.

Take a moment to review what you've made so far, to see if there are any themes or ideas that are really starting to bubble. If so, please know you have complete freedom to let that fuel what we are about to make together. If you're not quite there yet, don't worry! Maybe you haven't made anything yet, and you're just dipping in and out of this book. You can start right here and now. Just start when you are ready.

MOVING THINGS ABOUT.

I want you to think about the context of things. A urinal in a public toilet has a completely different meaning than a urinal in a gallery. My giant balloons would have meant one thing at a wedding or birthday party and quite another in a public square.

LET'S GET SHIFTING!

Look around you and explore your home to identify four objects you find interesting. Maybe you find a toilet brush, a vacuum cleaner, or a tin of soup.

Place the items in front of you and look at each one. What do they mean to you in your home? Do any of them resonate with the ideas you hatched in the last chapter?

Now, grab a sheet of paper and start to write a list of locations that are accessible to you; don't pick anything too hard. Examples might be the library, the park, a coffee shop, or a church. Be realistic and give yourself an easy life by picking places where you actually go.

moment to review what
made so far, to see if
re any themes or ideas
e really starting to bubble.

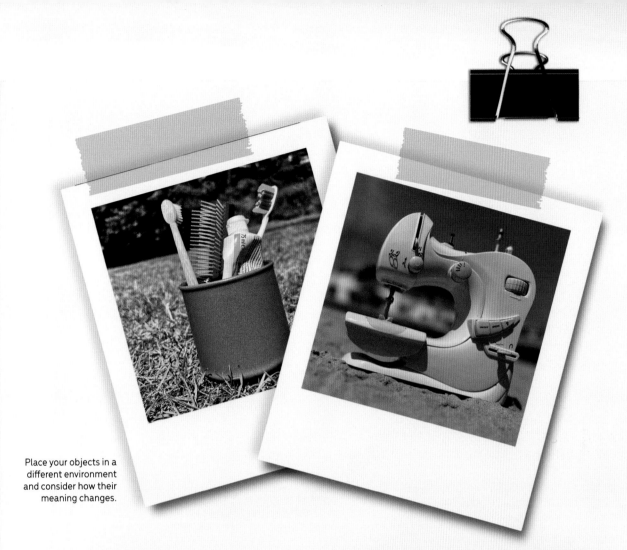

Place your objects in a different environment and consider how their meaning changes.

IT'S TIME TO MOVE IT.

Pick one of your objects. I've got myself a roll of toilet paper. Now, visit at least one, if not several, of your locations.

Be brave: Take your object there and install it.

Take a moment to consider what it means here. Why does this feel so different? What does this thing mean in this context? Do you feel like this was a success, or did it fail to really deliver an idea?

Document your action by taking a photo and, if you like, sharing that photo on social media with #makeartordietrying so we can all see it.

Make it a habit to document your progress because any of the things we do together might just be seeds of inspiration for future work. Hopefully, you'll look back on all this documentation and start to see themes and interests develop. This will be the fuel for so much. I'll be banging on about documenting your progress a lot. Sorry if I become a broken record, but trust me, it's so powerful!

Hopefully, you've pushed through a little bit of the fear barrier and can see the power that you, as an artist, have to transform objects into art. Maybe this has inspired you to make other work. Good!

YOUR TURN TO MOVE

MOVE MORE.

Right, here's the challenge. Don't freak out. Set an alarm on your watch or phone, or just look at a clock. You have thirty minutes to collect any interesting stuff you can find from your local neighbourhood—obviously without stealing or upsetting anybody. The rest of the rules are:

- You need to be back where you are now in thirty minutes.
- You need to have collected several things.
- These things need to come from below waist height.

Ready? Three, two, one . . . go scavenge! I'll see you back here in thirty!

ASSESSING THE HOARD.

Hopefully, you are looking at a collection of things. Depending on the environment you are in, those things will differ massively from what I, or others, may have.

We are now going to work together to combine them, to assemble them into a sculptural form. These found objects will create something interesting. If you completed the Ideas chapter, consider picking a concept you uncovered there and see whether you can bring a sense of that into the way you combine these new things.

Set your alarm again, or look at a clock. You have thirty minutes to make your piece! The time restriction matters; I want you to be spontaneous. Don't think too much, just do. I find putting on music whilst I work really inspires me. Maybe that will work for you, too. Let's go!

ARE YOU DONE?

What kind of sculptural form did you make? We've talked previously about putting things in places you don't normally find them; here, we've done almost the opposite—bringing stuff from the outside into the home. We've shifted the context but we've also put things together to create new meaning. In art, we call that an assemblage. Robert Rauschenberg (American, 1925–2008) called it a "combine."

Take a minute to ponder your assemblage and reflect.

Take a photo to document your work, and, if you like, share it with all of us on social media with #makeartordietrying. I'm very excited to see what you made! Well done. That isn't easy to do. If you actually got up and moved, not only yourself but also some objects, that's huge. You should feel very proud. Reading about art is one thing, but actually doing it is quite another. It takes bravery. A book on swimming would be fine, but until you actually get into the water, it's kind of pointless. Art is a practice; it's something you do. The more you do it, the more depth it will have and the more it will evolve. Go take a well-earned rest and I'll see you in the next chapter, where we'll take a deep dive into performance art.

SCAN TO VIEW AN EXCLUSIVE VIDEO FROM STUART!

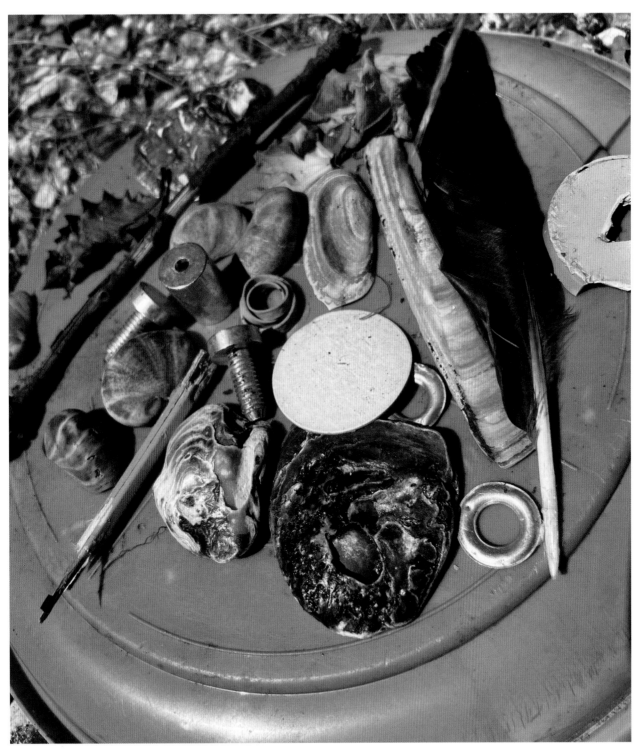

Access the items you found and begin combining them into a sculpture.

IT HAPPENS

kings that appen are appenings.

HA
NS

You're an artist a
to positively disr
only way change

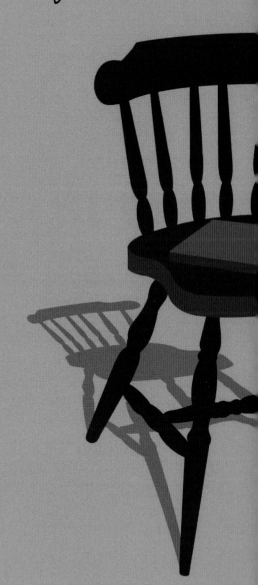

IT HAPPENS

JUST WHAT IS A "HAPPENING"?

I flipping love happenings! They are one of my favourite types of art because they give us permission to put aside making objects to zoom in on creating scenarios for our audience to have an experience. They are temporary, erratic, and unpredictable, just like real life. In these pieces, the artist gets out of the way and the audience gets the power to control the destiny of the work. Nice!

Allan Kaprow, *Yard*, 1961
Kaprow filled a space with hundreds of car tyres, in no particular order, and
encouraged visitors to walk on, climb, rearrange, and interact with them.

This might be a bit controversial; I can feel the heat of art historians' crosshairs on the back of my neck as I write this, but I'm going there anyway. Happenings haven't stopped happening. They weren't some moments in the late 1950s and '60s that ended. The first wave of happenings made such an impact that we are still feeling the reverberations now in the form of illegal raves, theme parks, flashmobs, online video hangouts, virtual worlds, and marketing stunts. Before we get to today, let's take a look back to how this all started.

In 1959, Allan Kaprow (American, 1927–2006) coined the term "happening" when he presented a series of works at the Reuben Gallery in New York. Shortly after, several other artists also started to create these events, which morphed into the performance art we know today.

Before then, when artwork was finished, it was done. It was static, preserved in time, never to change again. Happenings, literally, happen in the moment, free from the ticking of the clock and immune to having to be immortal. They would never become an heirloom that would be flogged on by the great-grandkids that find them boring. At best, all that remained were photographs after an event, or a bit of film, but often just a memory of an experience in someone who was there. A memory few could describe much better than, "You had to be there, man."

THE AUDIENCE IS THE WORK.

The key feature of a true happening was its focus on the audience and the radical idea that the audience were co-authors of the work. Basically, they were not just passive bystanders, but actually became active participants, often with the power to control the outcome.

Because these happenings played with the "here and now" of the real world, they often incorporated elements that people recognised—you could even call those elements popular. Perhaps they were car tyres, words from advertisements, or well-known images. The fact is, this work was the forerunner of not just performance art, but, in a way, pop art as well. Actually,

Kaprow himself said there was more inspiration in the phone book's yellow pages than in classical art because you could find funeral directors, car garages, and cleaners.

A happening could happen almost anywhere, not just in galleries and museums, but also in caves, streets, and farms. The plan was to make the boundary between art and real life really blurry. Since the 1920s, artists have been trying hard to break through the conventions of what art itself was and to push the boundaries of what it could be. To do that, this new generation of artists working with happenings wanted to abandon the lot—anything that felt like art was binned; it was full of too many rules and systems. Art was for far more than looking like itself. It had a job to do, and that meant it needed to cut itself loose from the past.

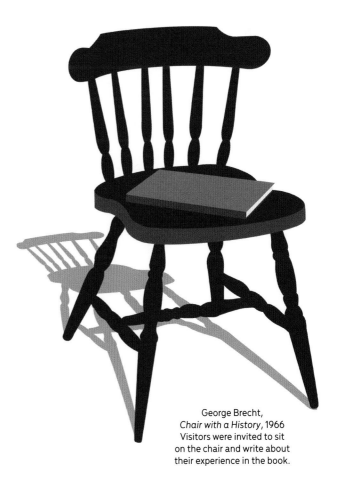

George Brecht,
Chair with a History, 1966
Visitors were invited to sit
on the chair and write about
their experience in the book.

HOW TO MAKE A HAPPENING.

In 1968, Kaprow gave a lecture on how to make a happening in which he laid out eleven rules. If you've got ten minutes, look it up online; it'll inspire you massively. He goes to great lengths to try to convey the idea that a happening should not look or feel like art, it shouldn't look like theatre, and it shouldn't be done more than once. It's vital that it's not rehearsed and perfected. The more it's indistinguishable from real life itself, the better. He says, "A happening is for those who happen in this world, for those who don't want to stand off and just look. If you happen, you can't be outside peeking in. You've got to be involved physically."

A great example is one of Alan Kaprow's most well-known works, *Yard*. Originally staged in 1961, he filled a gallery with used car tyres and invited visitors to climb on them. The tyres ended up being organised by the visitors into piles, and the participants added the risk of chance to the outcome.

Happenings don't need to be that elaborate, though. It was 1966 and George Brecht (American, 1926–2008) grabbed a wooden chair and a red leather book. He then invited participants to sit on the chair and write what happened in the book, making its history as they went. It's an example of the artist giving total control of the work to the viewer and a great example of how simple a happening can be: just one person's experience of writing and sitting.

By the end of the 1970s, happenings had morphed into "ins" such as "love-ins." Maybe the most famous "in" was John Lennon (English, 1940–1980) and Yoko Ono's (Japanese, born 1933) "Bed-In," in which they spent a week back in 1969 in bed at the Amsterdam Hilton. The world's media became the participants and the suggestion from John and Yoko was that they talked about peace, in the shadow of the Vietnam War.

John Lennon and Yoko Ono, *Bed-In for Peace*, 1969
John and Yoko stayed in bed at the Amsterdam Hilton.

"THERE IS MORE INSPIRATION IN THE YELLOW PAGES PHONE BOOK THAN THERE IS IN CLASSICAL ART."
—ALLAN KAPROW

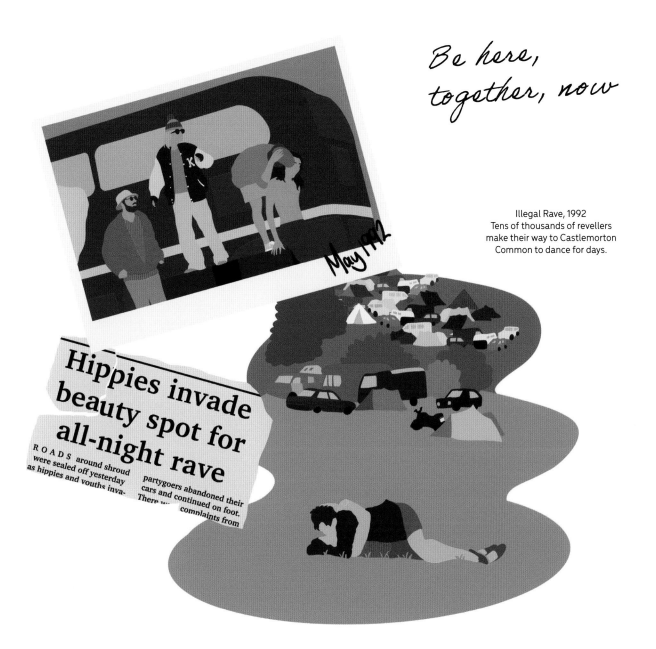

Be here, together, now

Illegal Rave, 1992
Tens of thousands of revellers make their way to Castlemorton Common to dance for days.

May 1992

Hippies invade beauty spot for all-night rave

ROADS around shroud were sealed off yesterday as hippies and youths inva-

partygoers abandoned their cars and continued on foot. There w... complaints from

IT'S A RAVE, DAVE.

I was twelve years old in 1992 when I saw a news report on a hot holiday weekend. Twenty thousand people descended on land in the shadow of the Malvern Hills in the English countryside. The word was spread by an answering machine message: "Right, listen up revellers. It's happening now and for the rest of the weekend, so get yourself out of the house and on to Castlemorton Common . . . Be there, all weekend, hardcore."

The sound systems played dance music—loud. The lights pulsed into the night, decorations hung, and thousands of people danced for days. Was this one of the biggest spontaneous happenings the United Kingdom had ever seen? Is the fact it felt nothing like art exactly what made it a happening? There's no permission, and perhaps it was unlawful. The organisers probably didn't see themselves as artists, but I'm sure the early pioneers of happenings would have approved, and that DIY approach stayed with me forever.

IT HAPP ENED FOR ME

IT HAPPENED FOR ME

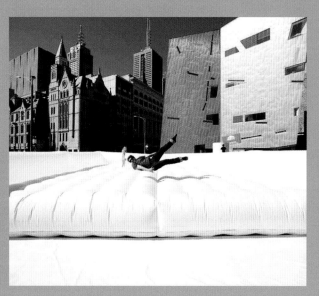

Semple, *JUMP*, Federation Square, Melbourne, 2013

I've always loved the idea of making something happen and then getting out of the way so the audience decides the direction. Nine out of ten times, when the work starts, I'm at home, on the other side of the world in bed watching an episode of *Poirot*. I believe the best happenings are when the artist disappears.

Leigh Bowery (Australian, 1961–1994) used to do it at parties in the 1980s in London. He'd start a rumour, or spread some gossip about people in the room. After stirring trouble, he'd go home and leave the carnage to unravel itself without him.

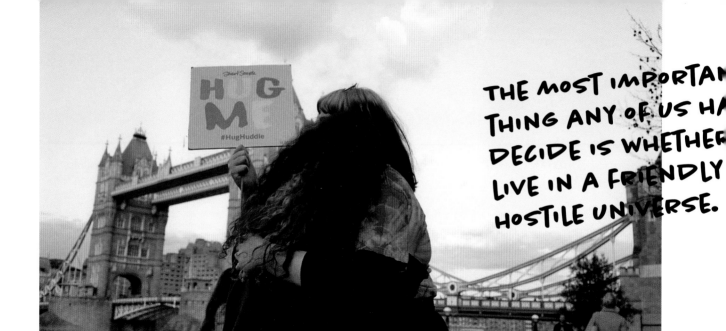

Stuart Semple, *HugHuddle*, Tower Bridge, London, 2018

THE MOST IMPORTAN
THING ANY OF US HA
DECIDE IS WHETHEI
LIVE IN A FRIENDLY
HOSTILE UNIVERSE.

HUGGING IN PUBLIC.

Happenings should really happen where people are. So for *HugHuddle*, we went out to Tower Bridge in London. The script was simple: A group of people hold up signs that read "Hug Me" and point them at passersby. It's strange to think of that in a post-COVID world, but at the time, I was really obsessed with the idea that technology was making us more and more antisocial, and that real human connections were missing. I've always felt like the level of risk aversion in society is disproportionate to actual risk. I mean, we worry way more than we should. Einstein was a very clever bloke, and he said that the most important thing any of us has to decide is whether we live in a friendly or hostile universe. I have decided most people are alright, and given the chance, they are more likely to do the right thing than not. But as with any happening, you need to give the audience the right to take it any way they want. Long story short, random strangers hugged each other for a few hours on their way home from work. Nobody got hurt, nothing went wrong and, as far as I know, the fear of the other, or the fear of the stranger, left for a little bit that sunny London evening.

MIGHT AS WELL, JUMP.

For Federation Square in Melbourne, Australia, I was looking to do something that had a physical movement influenced by other people. I didn't want to make something that looked or felt like art, so I settled for a big, white, inflatable bouncing floor. There were no instructions except the title *JUMP*. Due to how the air is distributed, if one person jumps, it affects another and vice versa, so the whole thing becomes collaborative. At first, participants were nervous, but before long, they had an experience together in a public space that couldn't be replicated. The thought was that you could only jump in the present moment, not in the past or the future, so it was really an invitation to be here, together, now.

IT HAPPENED FOR ME

EMOTIONAL BAGGAGE DROP.

I heard that the most stressful part of most people's day is the commute. So, I worked with Union Station in Denver to test that. I installed *Emotional Baggage Drop*, which was disguised to look like a legit piece of station architecture, complete with the same wooden finish and Art Deco fonts found there. Inside, a thin wooden wall separated two random strangers, connected only by a small eye hole. Picture a confessional box in a church and you're probably close to what this was like. One stranger would read out a statement asking the other stranger if they had an emotional burden they wished to check. Then, they listened attentively to the response before thanking them and letting them know that their emotional baggage had been checked and they didn't need to carry it around anymore. This process repeated as a line of people entered and exited the booth, each hearing the other's burdens in a kind of chain reaction. The result was interesting. My friend Charles Montgomery, who wrote an amazing book called *HappyCity*, did a study on *Emotional Baggage Drop*, and it turns out, those who used it were more likely to believe that if they lost their wallet it would be handed in than those who hadn't participated in the work.

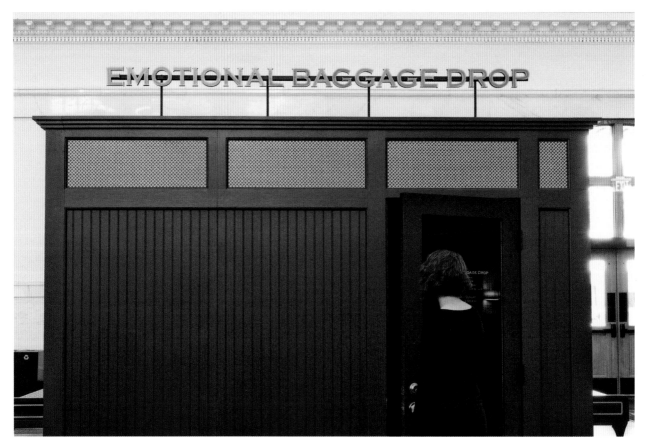

Stuart Semple, *Emotional Baggage Drop*, Union Station, Denver, 2018

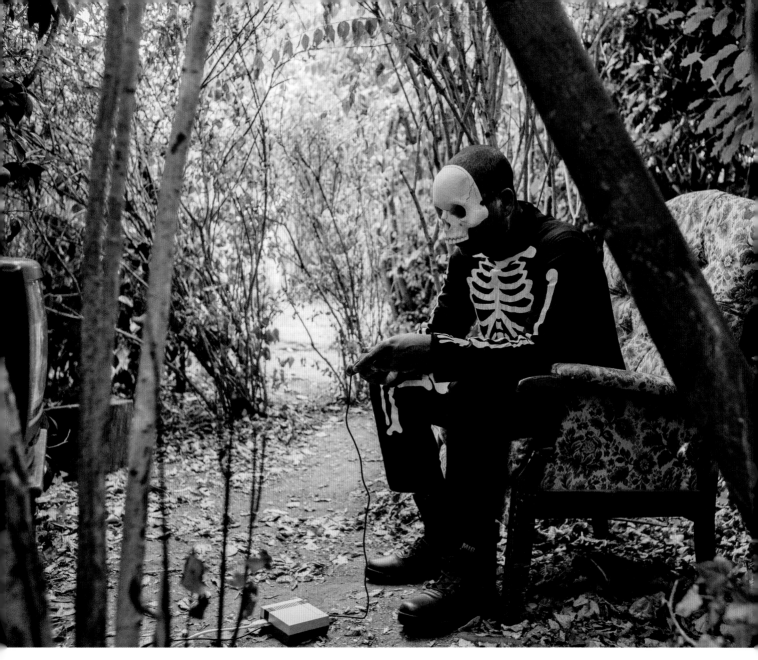

Stuart Semple, *Game Over*, skeleton plays Mario. Photo by Sarah Morris

HAPPINESS IS . . . SOMETHING ELSE.

Something Else took place at the Dulwich Picture Gallery in London. I'm not even sure where to start describing this thing. It's definitely one of those "You should have been there, man," moments. It was a complex happening that involved me making several environments and installations across the grounds of the gallery.

Visitors received a passport and a path. Scout-type tent structures housed graveside scenes where participants could make wax crayon rubbings of an epitaph. Characters dressed as skeletons played Super Mario on retro TV sets in the bushes, and every half hour Mr. Wolf instigated "What's the Time, Mr. Wolf?" A girl on a bike with a boom box gave out red balloons, whilst a dancer wafted through the gallery and a photographer shot the participants trying to balance

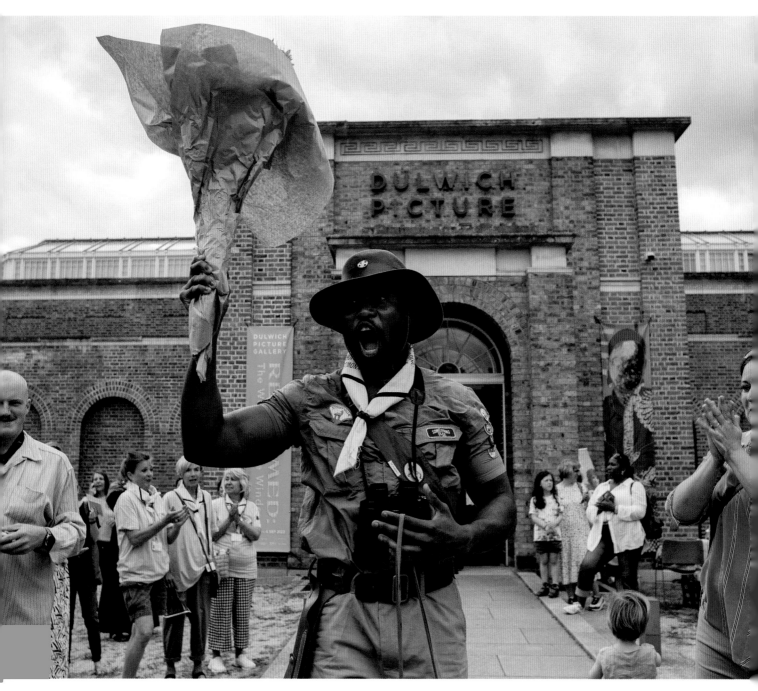

A scout leader leading. Photo by Sarah Morris

boulders on a seesaw. Scout leaders rallied the public to paint a giant mural, and stalls of retro collectible toys nestled amongst tents that looked like a 1970s roadie had slept in them. Every now and then, a fortune-teller would tell you what was in the cards for you.

(Opposite) Stuart Semple, *What's the Time, Mr. Wolf?*; Participants. All from Dulwich Picture Gallery, 2022 Photos by Sarah Morris

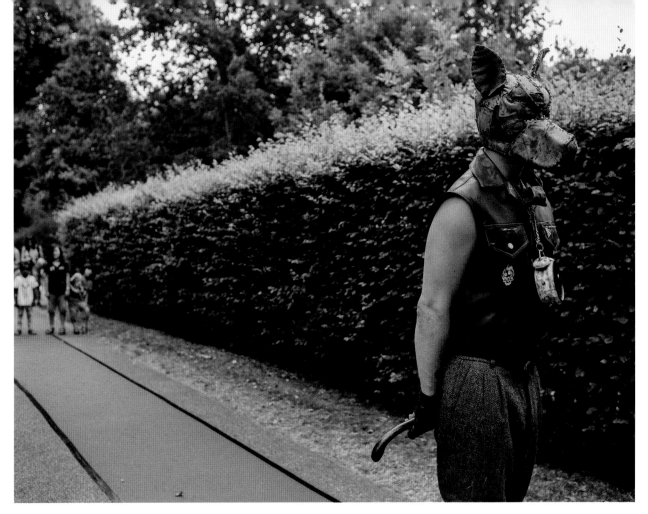

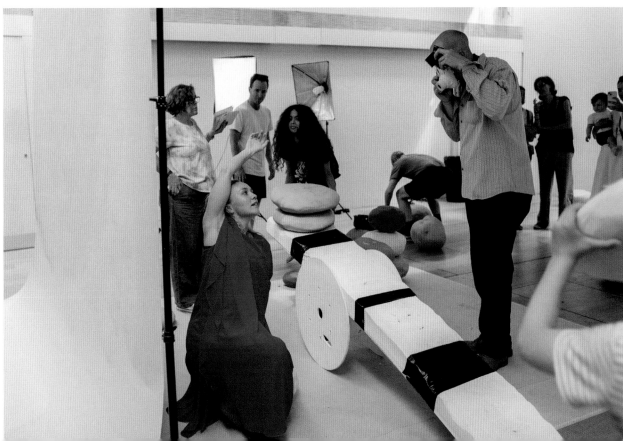

MAKE IT HAPPEN

Okay, so now we've delved a bit into the history and evolution of happenings, and you should have a decent enough sense of how these things work. The time has come to put some of this information into action in your life to, hopefully, bring some delight and connection to your community. My advice is to start small. Doing this does take a bit of nerve and some confidence. You can take this as far as you want, but I will remind you that laws are there for a reason, and I really don't want anyone getting into trouble—or hurt. Keep it fun and safe. There's probably a lawyer somewhere who wants to tell you that neither I nor the publisher can take any responsibility if you get in trouble for any of these escapades. So, don't take any stupid risks, but be brave enough to push past your comfort zone. You're an artist and it's your job to positively disrupt: It's the only way change can happen.

BE BRAVE AND DON'T MAKE IT LOOK LIKE ART.

Remember, it shouldn't look like art, it doesn't need to be pretty. It just needs to get people to join in and have the flexibility for them to make it their own. It's as much a practice of creating a moment as it is of letting that moment go.

Perhaps before you explore these ideas, think of a few themes that move you, or topics close to your heart, that you can base these works around. If not, maybe do one and let the results suggest ideas for your next happening. These are just ideas I came up with to get you started—the more you deviate from them and make them your own, the better; don't let me tell you what to do, except that you must do something.

The lesson here is one of bravery and action. We live in a time where very few people actually have what it takes to leave their home or studio and really do something. Don't be one of them. All good things happen to those who try.

Good luck!

Filling in the blanks.

THE SCRIPT.

Let's write a little script together. Grab a piece of paper and a pen or pencil and copy this out, filling in the blanks as you go.

_____ join together _____
(number of people) (where)

holding _____ at _____
 (what) (what time)

to _____ whilst making
 (do what)

_____ and people can join
(what sound)

in by _____ and it lasts
 (doing what)

until _____
 (how long)

Fill in the blanks.

Now, send an invite to the people you need, telling them where and when to meet you and what to bring. Don't tell them much else, just let them know you are staging a happening and you need a hand.

Here are a few ideas to get you started.

Number of people:
One, loads, hundreds.

Where:
A supermarket, a field, some coordinates, a virtual world, or a public place such as a city square or plaza.

Holding:
A banana, drums, cream cakes, pets, candy, nothing.

At:
Sunrise, midnight, 3:18 p.m., any time they fancy.

Sound:
Mooing, no sound, laughing.

Doing:
Line dancing, lying on the ground, jumping and clapping, gymnastics.

How long?
For one hour, until the sun comes up, when we get bored, when it naturally ends.

MAKE IT HAPPEN

THE OLD ONES ARE THE BEST.

Find something small and semi-valuable that you are happy to live without. Maybe a coin or a ring. Grab some superglue and stick the object to the pavement or sidewalk. Very simple. Participants will endeavour to remove it without embarrassing themselves. Can you resist not watching and be a disappearing artist? Know that starting something is enough.

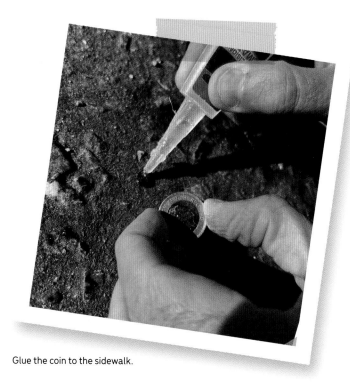

Glue the coin to the sidewalk.

A PLACE TO CHAT.

Take some chalk and find a public bench, then write the words: "By sitting here, you are happy to chat," on the ground in front of the bench. You've just made a place where a happening can happen. Your job is done. Why not go home and celebrate with an early night and your favourite TV detective show, you wonderful mischief-maker you.

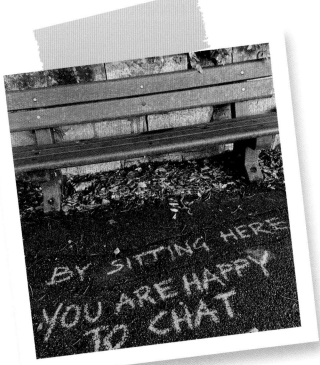

Behold, a public chat station!

HELLO, STRANGER.

1. Gather a piece of string, a pen, tape, and a notebook.
2. Tie the string to the pen and tape the other end of the string to the notebook, just so the pen and book are connected.
3. On the cover of the notebook, write the words "Hello, Stranger."
4. Inside, on the first page, write some instructions for participants:
 - This is a piece of artwork by [your name] and you are now part of it.
 - Please answer the last question in the book.
 - Leave a question for the next person.
 - Put the book back where you found it, so I can collect it at the end of the day. Thank you!

Then, write your question in the book to get things started. Maybe something like: "Do you like dolphins?" "Are Pop-Tarts a balanced meal?" Or, "If you could, would you abolish the British monarchy?"

Leave the book and pen in a public space (a library, coffee shop, bus stop, etc.), and collect it later.

Leave it where they'll find it.

SCAN TO VIEW AN EXCLUSIVE VIDEO FROM STUART!

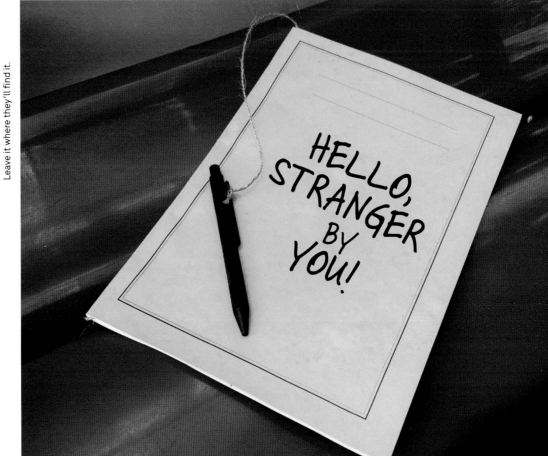

HELLO, STRANGER BY YOU!

PERFORM

Your life is performance.
Performance is art.
You are art.

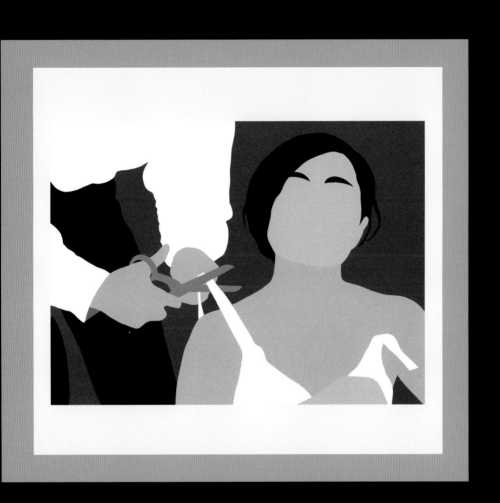

PERFORM

PERFORM

ife has a changeable, emporary, immaterial ature.

**YOUR LIFE IS PERFORMANCE,
PERFORMANCE IS ART. YOU ARE ART.**

Let's think about performance and the idea that the
way we perform something can be art. We will enter
a magical space between art and life where the artist
can challenge how we relate to the wider world around
us. From playing soccer on stilts to following strangers
around New York City, the world of performance is
waiting for us to jump in.

THIS TOO SHALL PASS

Life has a changeable, temporary, immaterial nature. The early pioneers of performance art wanted to make their work about exactly that. The big thing here was that artwork with an element of living in it was much closer to real life than a static painting or sculpture. Again, these artists wanted to step outside of commerce and make art that couldn't be bought or sold. To define performance art: We are talking about works with a life element that are witnessed by an audience. Saying that, as performance took hold, people realised that even paintings and sculptures could have a performative side to them. Just think about the way Jackson Pollock chucked paint around in his drippy flowy "action" paintings.

In the end, almost everything seemed to have an element of performance in it, and the question wasn't what *is* a performance, but more what *isn't* a performance?

IT'S NOT WHAT IT'S MADE OF.

The main thing to understand is that performance has nothing to do with the medium, the stuff it's made of. It's much more of a tool artists use to help us think about how we relate to art and the wider world around us. Most of the time, performance art will, of course, have a live-action element and an audience, but it doesn't always have to.

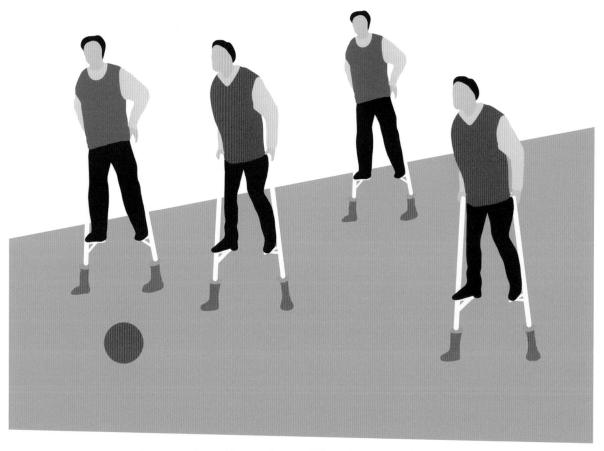

Conceived by George Maciunas, *Soccer on Stilts at the Flux-Olympiad*, Tate Modern, 2008

The m
that

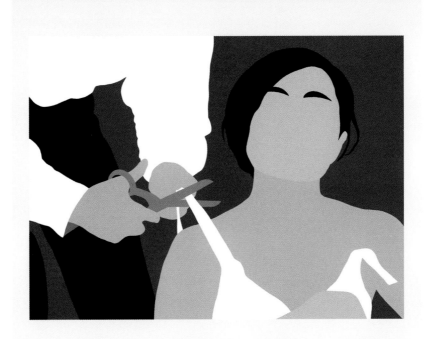

Yoko Ono, *Cut Piece*, 1964

Sometimes, it can even be a document, such as the *Flux-Olympiad*, that George Maciunas (Lithuanian American, 1931–1978) created for an artwork but never got to see created during his lifetime. He thought art should appear in every part of life—even sports. He was a bit cheeky, though, so he came up with things like soccer on stilts and a running race with people wearing flippers. In 2008, thirty years after his death, the Tate in London used his instructions and, finally, brought the *Flux-Olympiad* to life.

NEVER SETTLE DOWN.

Performance lives in a magical space between art and life, and it's in this gap that we can make sense of the constantly changing world around us.

Robert Rauschenberg probably explained it best: "Art that refuses to settle."

I thought it would be useful to look at some of my favourite moments in performance art history.

GIVE THE AUDIENCE POWER.

I can't write about performance art without touching on Yoko Ono's *Cut Piece*, which she first performed in Kyoto in 1964. The idea was simple: Yoko put on her best suit and sat alone on a stage with a pair of scissors in front of her. Then, she invited the audience to cut off a piece of her outfit, which they could keep. Some hesitantly took a tiny square, and others made more violent gestures, cutting away her bra or revealing her nude form. It continued until Yoko felt it was time to stop. It's hard to see now just how groundbreaking this was at the time. It really was a piece of work that changed everything, particularly as it gave the audience control of the work. They were vital in it happening.

HOW DO WE APPROACH IT?

How we approach performance art as an audience is fascinating. Often artists take us outside our usual places of experiencing performance, and they require us to join in at least to some extent. The rules we find around the cinema or the theatre just aren't there with performance art. The best artists seem to lean in to that place of limbo where the normal audience/performer relationship becomes blurred.

thing to understand is
...ormance has nothing to
...dium, the stuff

FOLLOWING ACCONCI.

Let's talk a little about one of my favourite artists of all time, Vito Acconci (American, 1940–2017). He really pushed the boundaries—always pushing against the edge of what was acceptable—or decent—whilst staying brutally honest. He created so much amazing work, some of it so challenging in its subject matter that it's beyond the scope of this book, as I want to keep things open to everyone. So, I'm going to focus on one of his simplest, yet most profound, pieces, called *Following Piece*.

It was the autumn of 1969. Acconci was in New York City ready to choose a passerby at random who he would then follow until they entered a building. Sometimes, the event would be over in minutes, but other times, he would walk for several hours. He produced a map of what happened and explained it like this: "I am almost not an 'I' anymore; I put myself in the service of this scheme." Yes, it's a bit creepy to be stalking people in public, but what a genius way for the artist to surrender his control of a piece of work to let it direct his actions.

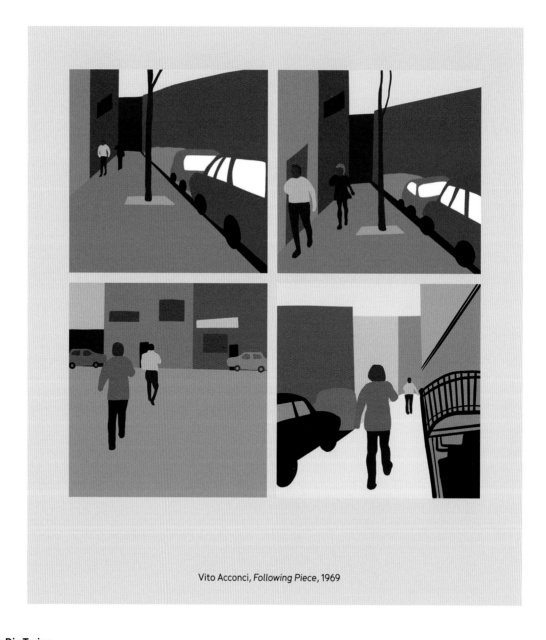

Vito Acconci, *Following Piece*, 1969

THE LIVE, LIVING ELEMENT IS TEMPORARY AND FLEETING BUT THE RESULTS ARE SOMEWHAT IMMORTAL.

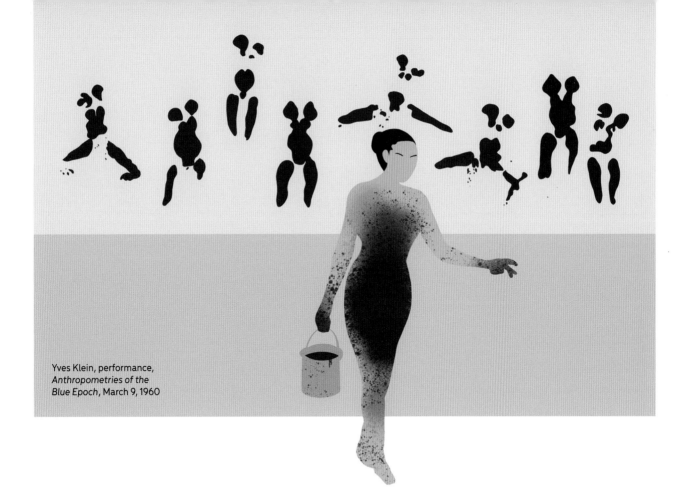

Yves Klein, performance,
*Anthropometries of the
Blue Epoch*, March 9, 1960

CONDUCTING BLUE PEOPLE.

The last one has to be Yves Klein (French, 1928–1962). Again, he created so many brilliant performances—from swapping the empty space in a room for a certificate and giving the owner the decision to complete the work by dropping the certificate in the river, or keeping to, perhaps, his most famous piece, *Anthropometries of the Blue Epoch*. For this, Klein specially created (and patented) International Klein Blue paint that was applied to women's naked bodies. The way it worked was, Klein would wear a bow tie and a suit, and an audience would gather. Musicians would play his *Monotone Symphony*, which was, basically, a single note that lasted twenty minutes followed by another twenty minutes of silence. Klein would conduct these naked women and they would cover themselves in paint and then act like living paintbrushes, imprinting their bodies on large pieces of canvas. It's a very interesting idea, where the painting

is a by-product of performance, almost a recording of what happened. The live, living element is temporary and fleeting but the results are somewhat immortal.

WHEN WILL IT END?

When we think about a performance, we can't help but think about something with a duration. But, at what point does it really start? Does it begin when the artist comes up with the idea or when the audience arrives? Does a performance simply stop when everyone goes home or does it live on in the memories of those who experienced the performance? If we record it, is the performance reborn every time it is replayed?

Let's look at some of the ways performance has shaped the things that I've been doing in my work over the years.

I PER FORM

I PERFORM

There's always been quite a strong performance element to my work; even when I'm painting, I feel like I'm performing. The finished paintings are like recordings of where my hand went and what I did.

When I work on paintings, I'm very much alone in my studio, the music blaring. They are physical—I'm jumping up and down and running around the place. With painting, the performance is private, and the result—if I show the paintings—is public.

I want to focus here on the aspect of my work that involves an audience, even those pieces for which the audience has control of their direction.

With painting, the performance is private, and the result—if I show the paintings—is public.

Stuart Semple, performance, *My Happy Place*, Coventry, 2015

POSITIVE PROTEST.

The first piece I want to share is a piece called *My Happy Place*. I've always loved the idea of twisting the idea of a protest: Rather than being angry about something, could the format be used to amplify something positive we might celebrate? For this piece, I got together with my friends in Coventry (they looked after the Coventry Centre for Contemporary Art [CCCA] at the time and ran an incredible community called The Pod, which was all about creating a nurturing creative space for those with mental health issues). I came up with the idea of a workshop where anyone could paint a placard, demonstrating their happy place. Some people said it was walking in the hills, listening to music, or eating bacon. Whatever that happy place was, they declared it on the placards, then, en masse, took to the streets of Coventry to march by several notable landmarks. Taking the form of a protest, on the surface it could have looked antagonistic, but the twist came when the public realised the work was joyous.

I PERFORM

MAKING HAPPINESS IS HARD.

Maybe my most famous performance is *HappyCloud*. The story is a little bit wild, but I hope that in telling it you'll get a sense of how to push to make an idea happen, and it might remind you that what's inside you is worth fighting for.

I was living in London in 2009, having established my-self as an artist and regularly selling my work and doing shows. On the surface, I appeared to be doing well, at least in a career sense, until one day it all turned. The recession hit like a ton of bricks. Banks were closing, my art dealers lost their homes, and the everyday person in the street was living under what the press called, "the credit crunch." I lost the glamorous studio, couldn't pay my bills, and was secretly homeless, sneaking into a building to sleep on a sofa with my partner and then-three-month-old child.

I showered at a local hotel gym and kept up the perfor-mance of everything being fine. Inside, I really wasn't. The constant doom and gloom of the news and the front pages were wearing me down as much as every-one else. Then, I remembered a newspaper clipping about a guy in the United States who had put helium through a Hollywood movie snow machine and made the snow float. I thought it was genius. I could see how, if you pushed the snow (made of soap bubbles, like dish detergent), through a stencil you could make eco-cloud shapes fly in the sky. I knew where to hire such a machine, and I had the vision of making clouds in the shape of smiley faces. The obvious location was Tate Modern, at that time about a decade old and really almost like a cathedral for me. I just had this image of smiley clouds above the Tate.

I had about 80 pence to my name and a new family to feed. I knew I needed to get my new cloud machine outside the Tate, and I knew I didn't want to get in trouble, which meant I needed their permission. It can take a while for a large organisation to respond to queries, and so things stalled. But, I learned that, in London, if you want to host a protest, let the police know and they'll give you a document saying it is allowed. I put in a proposal to host a small protest, with a box and two helpers on the Southbank—the protest would be against doom and gloom. Sure enough, the paperwork came back. I now had Metropolitan Police permission. Bingo!

Now, I just needed permission to get a vehicle on London's Southbank, which would need to be parked there, and about £1,500 ($1,800) to rent the snow machine and buy some helium. The first part came about by knocking on all the doors to the houses next to the Tate. Inside one of them lived a priest who needed money for his church roof: A £50 ($61) donation would secure a parking spot in front of his house and right next to the Tate for the day—perfect.

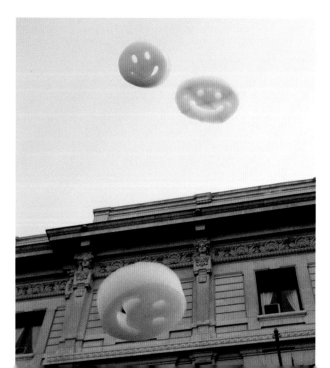

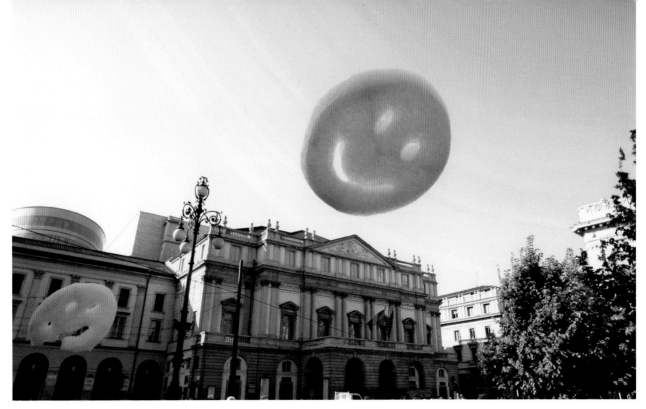

Stuart Semple, various performances, *HappyCloud*, 2008–2022

GET THE MONEY AND RUN.

The next mission was to get the money. The only option was to call my bank manager. Imagine a severely overdrawn, avant-garde artist: me. Ringing up the ever-patient Dianne at Lloyds explaining some half-baked idea about priests, protests against doom and gloom, and smiley-face cloud machines. Anyway, for some reason I still can't fathom, on that day, Dianne helped! She told me to walk into the nearest branch of the bank and pass my mobile phone to the cashier with Dianne on the phone. I did exactly that. The cashier handed me my phone back and £1,500 ($1,800) in crispy new £20 notes.

THE WINDS OF FATE.

The rest really is history. By fluke, the wind was blowing the right way and these clouds floated toward the struggling financial district. I saw the way they changed the atmosphere and seemed to spell out the idea that, at times like this, maybe art could help lift spirits. It completely changed the course of my work, and within hours, the images of the smiling clouds were all over the newspapers, giving everyone a break from the misery for a day. The *HappyClouds* have now travelled the world. I've let them off in Hong Kong, Italy, Canada, Denver, Moscow, and Australia. I love them so much and just want to share them with as many people as possible.

The moral of all of this is, if the idea is powerful enough, and you surrender to doing whatever it takes, the impossible just becomes a thrilling adventure. Never sell your ideas short by not putting in the work! There is always a way.

YOUR TURN TO PERFORM

I know the idea of performing strikes fear into the hearts of many artists. I get it; we chose art so we could stay on our own, make our stuff, and let it speak for itself. I'm a self-confessed introvert, so the idea of putting myself out there is nothing short of terrifying. So, rather than totally freak you out, I'm going to take you through a couple of exercises that will help you develop performance in your work. There are so many ways you can take this, so don't worry if you don't want to perform the works yourself; there's always the choice to create them and leave them unperformed. Just as we saw with the *Flux-Olympiad*, maybe, one day, someone will discover your rules and bring the work to life for you.

Let's start by loosening up a bit and doing a bit of performance, then I'll help you develop some ideas for your performances.

I'LL BE YOUR MIRROR.

The first piece I'd like you to do is taken from Kira O'Reilly's (Irish, born 1967) book *Performance Artist's Workbook*, and it goes like this:

- Take a hand mirror and hold it up to reflect the world around you.
- Move the mirror and observe how your viewpoint changes based on the mirror's reflection.
- Begin to move, only viewing the world from the surface of the mirror.
- Experiment with durations and environments, by yourself or in crowded situations where you can catch other people's glances.

View the world only on the surface of the mirror.

nber, we are now in the
cal space between life
rt. Let's stay here a
and daydream about
performances.

Organise your trash.

BE YOURSELF, BUT DIFFERENT.

This one is pretty easy, but also challenging in a way. Walk around the space you are in, in a new or different way. Maybe walk backward, jump, or hop. Perhaps move with your eyes closed, or crawl. The performance continues until you run out of innovative ideas.

TRASH CHALLENGE.

This next performance is very simple but, I think, slightly brilliant. Get a plastic bag and a glove. Head out to your local park, pick up some litter, and find a spot to organise your finds. Set some criteria for organising it,

such as sorting by colour, type, or size—you decide! Take a snap of your finds to document the results and then make sure you put everything you found in the trash bin. Good job! If you want to share what you made, you can post it on your social media with #makeartordietrying, so we all get to see it.

Now, you should be loosened up a bit and have an idea of what performance actually feels like. Remember, we are now in the magical space between life and art. Let's stay here a while and daydream about your performances.

YOUR TURN TO PERFORM

By now, you might be developing themes that interest you and that you want to explore further. Brilliant! Don't let me hold you back; you can start to develop those ideas into performance pieces. Let's brainstorm:

- Grab a piece of paper and a pen.
- Set an alarm for five minutes, then write nonstop, until the time is up, about all the things in the world you'd like to celebrate. Off you go!
- Okay now, same deal only with a different question: Write solidly for five minutes about all the things you'd like to criticise about the world.
- Circle a few ideas that really resonate with you.

OUR INSTRUCTIONS.

Now, it's time to get imaginative. What simple instructions could you give to another person that might convey your idea? For example:

- I asked you to walk around your space in a new way. We often get stuck in a rut and do things the same way without questioning them. I wanted you to explore the idea that you might have a lot more freedom than you think.
- Here's another one: Get a bunch of flowers and stand in a public place. Offer a petal to each passerby. The performance ends when you have no petals left.

See if you can come up with a few instructions for your idea. Keep them simple, and write them down.

Offer a petal to people you see.

Y NOW,
POSITIVE
AROUND YOU.
UND YOU IS
TLE BIT MORE

Distribute your instructions.

**SCAN TO VIEW AN
EXCLUSIVE VIDEO
FROM STUART!**

SHARE AND SHARE ALIKE.

I want you to finish by actually getting these ideas out into the world. There are so many ways to do that, but I think, for this, we will simply write them out. So, grab either a few pieces of paper or maybe even some index cards. Write your instructions on them—you can repeat yourself, if you like. Add your social media handle and #makeartordietrying so you can see if the work ever gets performed.

Once you've got a load of written instructions, it's time to get them out there. How will you do that? Are you going to leave a stack in a public place? Stand some-where and hand them out? Maybe paint them on little rocks and leave them around the place? Pin them to notice boards. See where your imagination takes you! If you did any of these things, well done. We are really starting to build a strong foundation that will support you making your work. You might actually, by now, already be making a positive impact on the world around you. Maybe the world around you is starting to feel a little bit more arty. Have a little break and I'll see you in the next chapter.

Remixing the culture
us is the best hope w
of understanding it.

STEAL

STEAL

STE

If there's nothing new under the sun, maybe the only thing we can do is take what's there and remix it into something else.

STEAL

STEAL
STEAL
~~STEAL~~
STEAL

**IF ALL ART IS THEFT, LET'S LEARN
HOW TO PLUNDER PROPERLY.**

If there's nothing new under the sun, maybe the
only thing we can do is take what's there and remix it
into something else. Picasso said that good artists copy,
but great artists steal. Let's consider how to steal with
style and how to turn those spoils into stuff that really
means something.

GREAT ARTISTS STEAL

Back in the day, artists would steal objects from the world around them. They'd paint a windmill or a flower, maybe freeze a landscape or the face of some king in oil. Sometimes, they'd even delve into the realms of their imagination. Nowadays, most of our lives, at least in the West, are much more about human-made images.

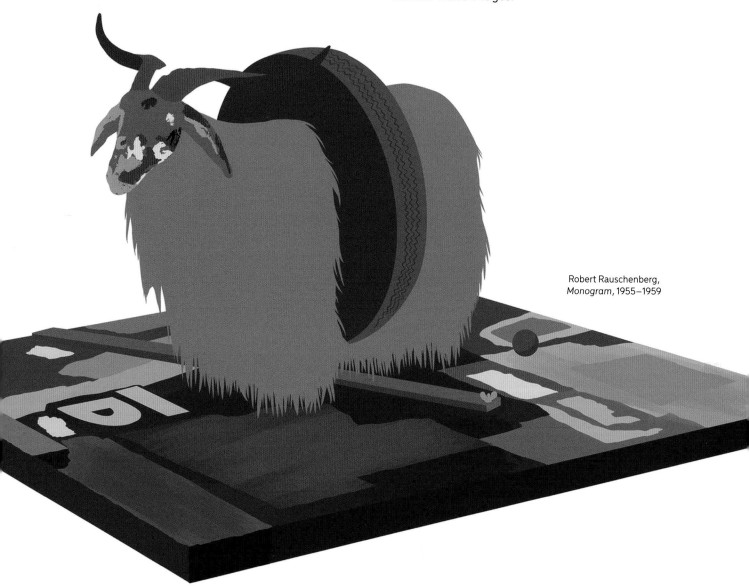

Robert Rauschenberg,
Monogram, 1955–1959

He didn't make anything n
to change the meaning of th
Duchamp

A CULTURAL LANDSCAPE.

We are surrounded by an almost-constant flow of images, inputs, and sounds. This defines our culture. It is the landscape we live in—maybe not a natural one anymore, but much more of a cultural one. I want to look at how we can be less passive and more powerful in that environment. I think you have the capacity to make brilliant work from these existing elements. I think stealing them, rather than merely copying them, opens you to the possibility of questioning them deeply, and even challenging them.

I've taken this approach for a long time. I'm not so pessimistic as to think there's no hope for a big, new, totally original idea, but I think the likelihood of me making such a gigantic leap is a stretch. So, I prefer to think of the way I can work with images like a DJ—sampling stuff and putting it back together again to make a new song. I like to think we are in a time of hybrids made by artists appropriating the world around them.

There's always been stigma around the idea of originality, that everything we do as artists has to be new. If the artist's job is to reflect the world around them, to be sensitive enough to pick up on the emotions and the meaning of it all and reflect it back to the wider group, then, perhaps, originality is a bit overrated. Maybe how we take existing elements and combine them to give people who see our work a new perspective on what they might take for granted is much more interesting.

Let's look at some examples of artists who have been doing just that.

ALL ART IS THEFT.

It could have started way back when Georges Braque (French, 1882–1963) and Picasso took images from newspapers and stuck them in their work. Anything you collage is appropriation.

Richard Prince (American, born 1949) is often in trouble for using other people's work in his work. He saved a heap of selfies from Instagram and printed them for a gallery show. He didn't make anything new, except to change the meaning of the pictures by moving them, Duchampian-style, into a gallery. He got into the most bother for using an image of a cowboy from a Marlboro cigarette advertisement. He stole the Marlboro Man by rephotographing the ad in a series of works that went on to sell for millions and millions of dollars at auction. Bearing in mind that all four actors who played the Marlboro Man have died from smoking-related diseases and that the original images were intended to do nothing more than to make people buy cigarettes, Prince gave the image a new use, one in which he asks us to question the reality of the image we are being sold. Dare I say even the morality of the corporations constructing those images?

ARTISTIC LICENSE.

There's a law in the United States that protects artists who use existing stuff; if the use is genuinely satirical and critical, there's an allowance for that kind of freedom of expression—and that's something Prince has relied on time and again. He often wins, and, sometimes, he loses. It's a tax he's willing to pay to make his point.

We've all seen Andy Warhol's (American, 1928–1987) prints of Marilyn Monroe, or his use of Campbell's soup cans. It's the same thing, taking what exists and moving it out of its place in culture and reflecting it back through art. He takes low art and smashes it into high art, and the rest is history.

Robert Rauschenberg was at it, too, often bringing images from popular culture, like JFK, the moon landing, dancers, flowers, or bridges, and collaging them together in gigantic paintings. He didn't stop there, though; he created complex assemblages that incorporated paintings with objects. He created a whole new category he called "combines." My favourite is *Monogram*, a work that combines a ram's head, a tyre, painting, and found bits from old signs.

cept
ures
le,

In the 1930s and '40s, Joseph Cornell (American, 1903–1972) would rummage through thrift stores in New York City, finding dolls, trinkets, and Victorian objects. He would then put them together in wooden boxes with glass fronts. These shadow boxes feel like weird childhood memories we are left to imagine. Here, the combination of the elements makes the story.

BRING THINGS IN FROM THE OUTSIDE.

Maybe my favourite work of appropriation is the wildly ambitious *The Clock* by Christian Marclay (American and Swiss, born 1955). He took sections of thousands and thousands of films that showed a clock, a watch, or the time. He spliced together all the clips to make a twenty-four-hour film that, literally, tells the time. I remember sitting at the White Cube gallery in London, back in 2010, mesmerised by the flow of time and all the different narrative directions these clips took. The gallery was open all day and all night. It was a truly groundbreaking piece and shows just how original something made from other people's work can be.

SITTING AT THE WHITE CUBE LONDON, BACK IN 2010, D BY THE FLOW OF TIME AND FERENT NARRATIVE DIRECTIONS S TOOK.

Joseph Cornell,
The Hotel Eden,
1943

Christian Marclay, *The Clock*, 2010

Really, when all is said and done, looking back, the defining moment of all of this was Richard Hamilton's (British, 1922–2011) *Just what is it that makes today's homes so different, so appealing?*—a small collage from the mid-1950s that captures the arrival of consumer goods in America through Hamilton's appropriation of images from American magazines. It shows the critical stance that Europeans took when looking at popular culture. It's the clincher, and you should look it up.

I've always loved the idea of bringing things into art that are normally left outside of it. Remixing the culture around us is the best hope we have of understanding it. Before you begin making your own remixes of the world around you, I'd like to share a few examples of things I've made out of existing things.

GENIUS IS OVERRATED

I've totally abandoned the idea of genius. The chance of me having a "eureka" moment in the bathtub is nearly impossible. Yet, I'm surrounded by so much content. The incessant social media flow of images and text, billboards, advertisements, and posters.

I go nowhere without my headphones in. It's like I'm walking through a movie: the world is in slow motion, the words of singers and songwriters subtitle the mundane to make it some kind of cinematic poetry. Even the supermarket becomes supernatural when Bob Dylan sings "Chimes of Freedom."

I have a need to make sense of all this stuff, the discharged everyday life.

As I work, I write chalky soundbites on a giant blackboard. Photo by Sarah Morris

I have a need to make sense of all this stuff, the discharged detritus of everyday life. The commercial signs tell us we're not enough and that we are a step away from that perfect image that will result in us being loved.

In my studio is a gigantic blackboard; I've always had one. As I paint, I write words, chalky soundbites that hover over the activity like a description.

I'D SELL MY SOUL FOR A TACKY SONG LIKE THE ONES YOU HEAR IN THE VIDEOS.

In the other room, I have a vast collection of style mags, going all the way back to the 1980s. Issues of *The Face* wrestle with covers of *i-D*, *Wonderland*, and *Hunger*. Each is full to the point of exploding with images, photos, and ideas. These are my favourite sources of inspiration. Each page is like a still from a music video.

Stuart Semple, *My Loneliness Is Killing Me*, 2015

GENIUS IS OVERRATED

I obsessively collect and collage them. Making little compositions, sometimes in my sketchbook, sometimes even on the computer.

I see them as demo songs that, one day, I'll paint big. One day, I'll go into my painting studio and record them, forever and ever on canvas.

I love the idea of bringing together things that shouldn't sit together, images that fight to make sense. I love the moment when a phrase from a singer seems to resonate with an image and help it take on a new meaning. This, for me, is appropriation, building up the future from the ingredients of the past. I don't mind not being original, and I don't care about imagination either.

THE SURFACE IS A PRAYER.

The surface on which these things get captured together, that little square of painting or collage, is so infinitesimally small in the scheme of things. A little slice of matter in a universe of possibilities and ideas. Painters call that the "picture plane"; I call it a trap. On one side, you have the real world—you and me and the people who look at it. Through it, on the other side, is conceptual art, ideas, and possibilities. I love playing with the flat surface of pictures, even though they are frustratingly limited. Every single day, like some kind of wonky religion, I enter that picture plane. What I do is more like a kind of service or a prayer than it is a hope to make anything. The Holy Grail is that these appropriated words and images might surprise me somehow, and their uneasy tension will make me feel a bit better about myself as I move them around each other. I love the familiarity of symbols we know; it makes the work accessible and familiar. Song lyrics do that, a bit like smells—they remind us of a place and time.

The image world killed history. It froze it, and it moves so fast that yesterday's social media feed was a lifetime ago. The atomic bomb was something that cast a shadow on my parents, bracing themselves under tables at school before blowing their teenage spending power on anything they could. When the end of the world is nigh, why not shop?

Did you know all the photos and films of Hiroshima were black and white? Not the hyper-real 8k CGI images we are used to today. So, I decided to appropriate it, add the colour, and bring the moment into art. I overlaid text from The Smiths song "Ask," because, quite honestly, if it's not love then it will be the bomb that brings us together.

BECAUSE IF IT'S NOT LOVE THEN IT'S THE BOMB, THE BOMB, THE BOMB, THE BOMB, THE BOMB, THAT WILL BRING US TOGETHER.

Stuart Semple, *Technicolor Hiroshima*, 2014

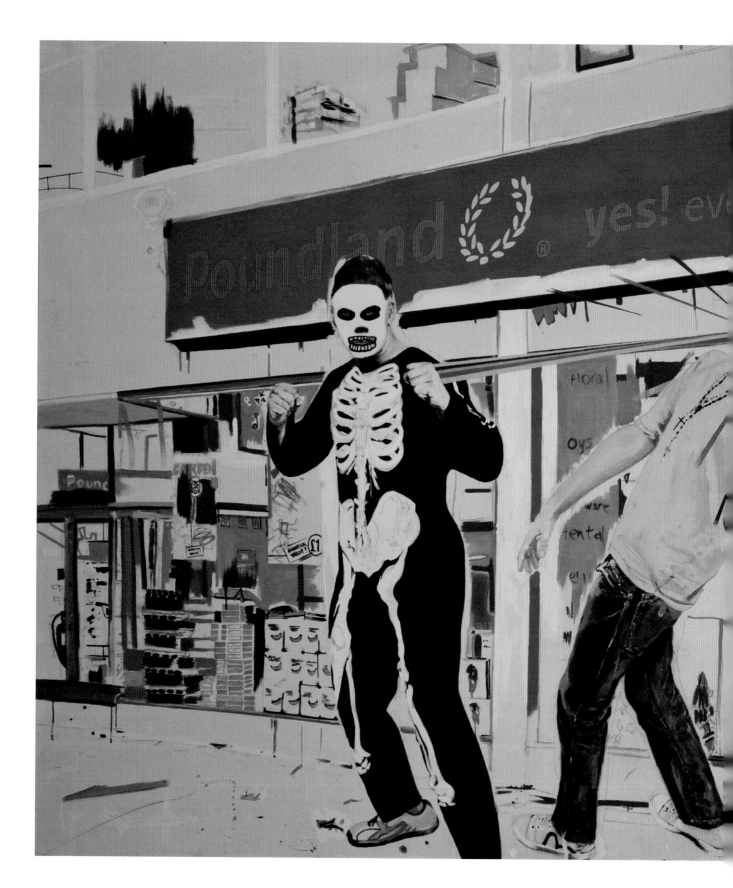

In my *Poundland* painting, I use well-known symbols, that of a High Street shop that sells everything for a pound. My poor mum used to walk in there and ask how much things were; it was hilarious—everything was a pound, and that was the point! Anyway, it's a painting of a real-life experience of when I got assaulted, and I've used the symbols of a character who looks like they are from the *Karate Kid* movie and a self-portrait to try to understand what happened to me. I'm using what already exists to tell a story, but also to use the magic ingredient that only painting can control: time. I can be reeling before I'm hit. I can paint myself the age I was when I made the painting, even though I was beaten up as a teenager.

You have to use what's around you to understand where you are, and hopefully, if you're lucky, other people will connect with it and find out a little something about themselves, too.

Stuart Semple, *A Pounding Outside Poundland*, 2010

JOIN ME IN THE HEIST

You've seen how I use the images and words around me to make my work. Now, I thought it might be fun to take you through my personal process to help you make some of your own art.

Before we start, remember, there's a massive difference between unimaginative copying and using what already exists to convey new meanings.

Maybe Jean-Luc Godard (French and Swiss, 1930–2022) put it best when he said, "It's not where you take things from. It's where you take them to."

MORE LIKE A SONG.

When I make these works, I think a lot more like a songwriter or musician than a painter. It's a mind-set that really helps me.

When I start out making work, I'm looking for an emotional trigger and something to hang the work on, a central idea that can help it all make sense.

I start off by listening to a lot of music—music with words, and if a phrase or lyric stands out, I write it on the blackboard.

Sit down for thirty minutes and listen to some music. Any music will do, as long as it has words. You might find this more contemplative if you use headphones, but that's totally up to you. Grab your notebook and a pen and write down any lines that mean something to you.

CUT IT UP.

Now you have a list of lyrics or words, let's steal an idea from William Burroughs (American, 1914–1997)—the same idea that made some of the best Bowie songs of all time.

Cut up your lines and rearrange them on a piece of paper to make a poem.

WE ONLY SAID GOODBYE WITH
SLOW DOWN. YOU'RE DOING FINE
CAUSE I'M AS FREE AS A BIRD NOW
SPEAKING WORDS OF WISDOM LET IT BE
GROUND CONTROL TO MAJOR TOM
IS THIS THE REAL LIFE?
IS THIS JUST FANTASY?
MAKE A DEAL WITH GOD

Get absorbed in some music. Write any lyrics that resonate with you in your notebook.

MAJOR TOM

I'D MAKE A DEAL WITH GOD

SPEAKING WORDS OF WISDOM

IS THIS THE REAL LIFE?

MY LONLINESS IS KILLING ME

CAUSE I'M AS FREE AS A BIRD NOW

FANTASY?

HEAVEN IS A PLACE ON EARTH WITH YOU

IF I ONLY COULD

Cut up your lines and rearrange
them to make a poem.

SAMPLING ISN'T NAUGHTY.

Next, we need some images; they'll form a basis for a composition later. I call this process "sampling." In my studio, I have vast hard drives full of found images. I've been collecting them for decades, but now, with the internet, that's less important, as we have instant access to so many images.

As I've said, I love fashion and style magazines and I've found them to be an incredible source of imagery, so if you have any lying around, they can be a treasure trove for you; if not, Google Images is going to be your best friend.

JOIN ME IN THE HEIST

SCAN TO VIEW AN EXCLUSIVE VIDEO FROM STUART!

1. Go through loads and loads of images, either online or in real life. Don't overthink this. If something feels interesting, cut it out or save it. You need to collect a decent hoard, say twenty, of ingredients to make this work.
2. If you've saved them on a computer, print them out or find a bit of software that will enable you to collage them together. Photoshop is the obvious one, but if you can't afford that, type "Pixlr" into your browser and you'll get a free tool you can use online.
3. If you are doing this in real life, you'll need some glue and scissors.

Collect a heap of images from either magazines or online.

COMPOSITION.

Songwriters record demos. They get the bare bones of a song set before they record it. A lot of musicians these days compose their work by dragging elements around on computers to make them work.

Let's start to arrange your samples into a structure that feels like a song.

When I start to put these elements together, it's very intuitive. I'm not sure of the best way to describe this as it's more of a feeling than anything else. There just "feels like" a moment when things click and resonate. So, that's what you're looking for. You may find that less is more and you have the ingredients for several works in your samples already.

1. Take the elements and start to arrange them. Move them around, and put one on top of the other. Start to see the tension you can create by putting different images side by side. You might notice how colours change depending on what they are next to—images are the same. Now, we are looking at shape, colour, and form.
2. Once you've settled on a layout that seems to have something interesting about it, it's time to save your demo. On a computer, that's easy, just save it. In real life, glue it down.
3. Now, let's add the lyrics to the song. Go back to your words from the first part of this exercise. See whether a line, phrase, or word seems to suit, or give extra meaning, to the collage you've created. That is how we choose a title for the work. Often, at this stage, I pick something that will change later, but it's

Recombine your elements to make a collage.

Draw a grid of your collage to help you scale it up.

useful for me as it gives a sense of meaning and emotional direction as I work.

THE FINAL RECORDING.

The collage can, of course, be a final work, so feel free to leave it here. You've already appropriated existing imagery, made it your own, and given it some kind of narrative or new meaning.

For me, however, this is only the beginning. I'll take the collage into my painting studio and use it as a starting point to paint. I won't copy it, but it gives me a loose starting point so I can let myself go and see where the paint itself leads me as I work.

If you do want to record this into a final work, print your work with a grid over it, or grab some tracing paper and draw a grid over your collage. Take a larger surface, maybe a big sheet of paper, board, or canvas, trace the same grid on it, then scale up the work. If you've got access to a projector, use that. There's no shame—it's not cheating, just a way to save a lot of time. As you paint the work, challenge yourself not to copy it exactly but to riff off the starting point to shift it into something even more interesting.

Well, that's how I do it. I hope it's useful and you start to play about with this and make it your own.

If you're ready to move on, let me take you to the most radical art school of all time, a place where the rules broke and the boundaries between different artistic disciplines crumbled forever.

BAUHAUS

Out of the
was shatte

HAUS

. of war, convention
and collaboration
d.

BAU HAUS

BAUHAUS

THE SCHOOL FOR DE-SCHOOLING.

The most groundbreaking collaborative art school of all time tore down the walls between the disciplines of architecture, design, education, fashion, graphics, movement, painting, performance, product design, sculpture, and typography. Out of the ruins of war, convention was shattered, and collaboration was championed. Form and function finally got it on and birthed architecture, objects, and graphics that laid the foundation for usability, sustainability, and innovation. Let's look at how less really is more, and how we can make sure that the work we create actually works out there in the big wide world.

ONE WAY OR ANOTHER

When I was at school, I was convinced I needed to be a one-trick pony: a painter, a sculptor, or a designer. Until, one day, the veil was lifted, and I realised I could express my ideas in any medium that made sense. That realisation came through understanding the Bauhaus, so I want to share that insight with you. I absolutely love it.

Let me take you to Germany, early in the twentieth century, around 1910, and introduce you to a man called Walter Gropius (German American, 1883–1969), a truly remarkable architect and a force of nature. He took a factory and made its walls glass instead of brick, so the inside and outside merged. The function of the factory (to make stuff) was made better because the form of the factory enabled a literal transparency, where everyone could see what was going on.

We can't talk about the Bauhaus without mentioning wars, and the Great War, which ended in 1918, left Germany on its knees, absolutely knackered. However, as we often see in the history of culture, moments like the Bauhaus become hotbeds for experimentation, risk-taking, and radical new ways of doing things. There may not have been much money at the time, but there was no censorship and no sign of the Nazis yet.

LET'S GET IT ON.

Gropius wanted to create a school that would fuse together applied art and fine art, breaking down the dividing line between disciplines and birthing something entirely new. He wanted painters to be in the metal workshop, furniture makers to collaborate with performers, and graphic designers to daydream about buildings. What came out of all that was what we now call design, graphic design, industrial design, architecture, typography, and graphics.

see in the
-ments like
hotbeds for
-taking,
ys of doing

This modernist door handle, by Bauhaus founder and German architect Walter Gropius, was first put into mass production in 1923.

HE WANTED
WORKSHOP

Without the Bauhaus, none of us would have affordable mass-produced modernist furniture in our homes. This Ikea chair demonstrates how much the Bauhaus has influenced our lives by making mass-produced modernist design widely available.

There were many brilliant and inspiring artists floating around at the time, and Gropius recruited them to join the school. Looking back on it, it's a literal "Who's Who" of groundbreaking twentieth-century creators and thinkers. He called it "Bauhaus," which means "building school." The actual school may have moved through different buildings in its life, from Weimar to the city of Dessau in 1925, and then from Dessau to Berlin in 1932, but its philosophy remained the same and lasts to this day.

At Bauhaus, everyone was taught everything under one roof, and the course was a kind of compulsory foundation. When everyone had done a bit of everything, they were given the chance to specialise.

A CULT FOR CREATIVITY.

Johannes Itten (Swiss, 1888–1967) appeared at the Bauhaus in monkish robes, with a shaved head, and stinking of garlic soup, which emanated from every pore of his body. He started the school day with exercises and breathwork. His cult-like persona came hand in hand with the strictly vegetarian diet that Bauhaus students and teachers followed.

Then, there was Paul Klee (Swiss German, 1879–1940), or the Bauhaus Buddha, as he was known. He took on the job of teaching design theory, bookbinding classes, and stained glass. He emphasised how similar painting was to making a building, with both requiring a step-by-step process. He made sure that compositions for paintings could take their own load and remain stable.

TERS TO BE IN THE METAL
ITURE MAKERS TO COLLABORATE
AND GRAPHIC DESIGNERS

Marianne Brandt bucked the trend of men dominating the metal workshop when she created this iconic teapot in 1929.

Wassily Kandinsky (Russian, 1866–1944) was also a prominent figure; he came from Moscow after being heavily involved in cultural policy at home after the revolution. He taught analytical drawing and mural painting. He had a way of starting incendiary debates, with one of his favourites being to challenge the community with the idea that the three primary colours are linked to geometric shapes. Kandinsky argued that squares are red, circles are blue, and triangles are yellow. If you look at the work that came out of the Bauhaus, you'll find this code in all sorts of pieces—from objects to posters, paintings, and furniture.

There were so many huge ideas that came out of the Bauhaus, and I don't want to bog you down, so I'll give you a few really useful ones to take with you on your creative adventures.

KILL PRETTY.

The first idea is the absence of ornamentation, which, in Stuart speak, means chucking out the stuff that doesn't really matter. Forget all the frilly decorative nonsense and focus on what makes the thing work. Pretty things just for the sake of it can be abandoned.

IT LOOKS LIKE WHAT IT DOES.

The second idea was to unite form and function. Basically, balance what something is for with what it looks like.

One of the best examples of this concept is Marianne Brandt's (German, 1893–1983) teapot. She embedded herself in the metal workshop to make functional objects with forms that changed the world. The teapot is so satisfying to look at. Its aesthetics are close to a masterpiece, but its form supports what it does. The round body heats the water evenly. The handle is insulated and gives you a solid grip. The lid won't fall off when you pour your tea. There's a lot we can learn from her teapot when we think about the things we want to make.

BEAUTIFUL AND MASS.

The third idea is the balance of craftsmanship with mass production. It is possible for something to be beautifully made and mass-produced at the same time; to pull that off, there needs to be design embedded throughout the process—which feeds into the fourth and final big idea.

FORGET ALL THE FRILLY DECORATIVE NONSENSE AND FOCUS ON WHAT MAKES THE THING WORK.

KEEP IT SIMPLE, STUPID!

Keep things minimal. Not just because it looks hot, but because it means the production process itself is simple and efficient, not wasteful. With the Bauhaus coming out of the financial crisis existing at the time, it's easy to see why streamlining things mattered.

The big takeaway is that less is often more, and stripping things back to the bare essentials can create things that not only look gorgeous but also work. This approach touched so much and even inspired modern typography. People such as Joost Schmidt (German, 1893–1948) taught lettering at the school, defining what contemporary design would look like.

Everything amazing must come to an end, and, in 1933, the Nazis put a stop to the Bauhaus. Sadly, many of the artists weren't of German origin and ended up being deported, imprisoned, or even, tragically, killed.

THIS, TOO, SHALL PASS.

Gropius's ardent hope and desire to build something new from the ruins of Germany may have come to an abrupt end, but its reverberations are still felt today (there'd be no Ikea without Bauhaus). Almost every poster, magazine, or even the design for this book would be different. Imagine Apple without the balance of form and function.

Today, we take innovation for granted; we understand artists can work across disciplines and that the user experience matters. At a time when our environment is more important than ever, sustainability is vital, using less to have an effective impact is the name of the game. For all of this, we have Walter Gropius and his crew to thank. Let's not waste their legacy.

The Peter Keler Bauhaus Cradle was designed in 1922. Peter Keler took Kandinsky's idea of colours, shapes, and associations a stage further by creating his iconic baby cradle.

*The big takea
often more, a
back to the
create thing
gorgeous b*

ART HOUSE

An actual [place where] people could collide, [to]gether, and start to [...] they could make thin[gs for the] world they were in.

The thing that always struck me the most about the Bauhaus over many other moments in history is the sense that it was, at its heart, a building. An actual place where ideas and people could collide, learn together, and start to work out how they could make things for the world they were in.

I've always dreamed of having a place like that, and over the last twenty or so years, my studio has gone through many variations. In the early days, I was either in the spare bedroom or in a tiny studio, freezing cold with mice and no heat, on the edge of East London before the Olympics came and knocked it down. I've been lucky to have some mind-blowing spaces since, but now I understand that it's not what it looks like, but what happens inside that matters. I've reached a stage where I want to be around others because that experience can teach us so much more than what we can learn on our own.

WE ARE THE WEIRDOS.

At the time of writing this, my studio is a big, old Victorian house, near the beach on the South Coast of England. It's more likely than not haunted, but that's not the most interesting thing about it. It's a hive of creative activity, more like a community than a workplace. Yes, we make shows, performances, films, objects, and artworks, but really the entire thing is a

The studio crew in our uniforms.

Deep relaxation—the studio crew take a break.

Bauhaus-inspired posters by Stuart for studio activities.

hotbed of collaboration and creativity. It's a haven for those who might not quite fit in elsewhere. A sanctuary for artistic weirdos, and I mean that in the nicest way.

The way it works comes straight out of the Bauhaus. We start our week with qigong exercises, and then assemble as a group to share what's on our minds. We have weekly dialogues about ideas, and do yoga on Tuesdays. We eat vegan food together and we spend time in silence. When people join, they go through a process of rapid learning, an art foundation in a month.

They learn design, web, photography, cultural theory, and a bit of art history. Actually, a lot of the ideas in this book come straight from the studio onboarding, so I'm glad to share them with you, too.

Within the studio, we are obsessed with design and typography. That even comes through in the posters we have for our internal sessions. That design work can be traced straight back to the Bauhaus.

ART HOUSE

BAD DESIGN KILLS.

Good design really matters. I have a catchphrase: Bad design costs lives. And it does—bad art can't kill, but bad design will. A poorly designed seatbelt or high-rise building can be catastrophic. So, I try to design things that just work. To do that, you need a sense of economy and functionality. Every now and then something clicks and the form of something meets the function of it. Now, I'm not saying we've ever got as close as the Holy Grail of the Bauhaus, but occasionally we get close-ish.

One of the works in which I see this is the table I made a few years ago. This table is designed to be cut from a single sheet of plywood and is able to hold artwork inside. I'm really pleased with the form of it, and I love the materials.

SHOUT.

I like design when it carries out an idea, too, so its function is to give a meaning. One of my favourite bands ever is Placebo. My teen years would have been rubbish without that soundtrack, so I was really excited when they wanted to work with me to package their single, which was a cover of the iconic Tears for Fears' track "Shout." I wanted to create, with them, a piece of work around a physical vinyl record, and I had an idea that, as you slid the record out of the cover, it would literally look like it was screaming. Functionally, it held the record, but physically, it did a bit more than that. I like it as a piece of design that feels like art.

SENSE OF
ALITY. EVERY
NG CLICKS
HING MEETS

Stuart Semple, *I save your messages, just to hear your voice,* 2018

An interactive record sleeve by Stuart for Placebo.

The next thing I want to share is a little metaphysical, but stick with me. Do you remember how I explained that Kandinsky believed certain colours have specific shapes? I believe that sound and music are a more subtle form of solid things. Put another way, if a sound gets heavy enough it starts to take form. Artists can play with that form.

I made a series of works with an incredible cellist named Tamaki Sugimoto (Japanese, born 1995) who has played for, amongst many organisations, the English National Opera. Tamaki is so brilliant at playing that she exists outside convention. We worked out that we could communicate through our artforms and actually have a conversation. I could make marks with charcoal and she could play them like they were a musical score. I could then listen to what she played and I could paint that. What came about was a series of prints I made that I truly believe are solidified versions of her playing.

Stuart Semple, *The pain in distance*, in collaboration with Tamaki Sugimoto for English National Opera

BACK TO SCHOOL

Some of my favourite practical exercises came out of the Bauhaus. Obviously, it was, at heart, an art school and it had some visionary teachers. The main focus was on unlearning and undoing a way of looking at the world. Now, these "deschooling" exercises could go on for months and turn into huge processes of reflection and introspection; we can't do that here, sadly.

However, I've done my best to bring you some of the more straightforward exercises that would have actually taken place at the Bauhaus, I've tweaked them a bit to give you a proper taster. If you want to take it a little bit further, by scanning the QR code at the end of this chapter, you'll get to join me in my studio on a Monday morning and participate in our physical exercises. Why not give it a whirl?

BUT FIRST, SOME DRAWING.

You're going to need some paper and something to draw with. I'd love that to be decent-size paper and charcoal. The whole exercise is better if you can involve more of your body in what you make. When we have small drawing tools, like a pencil and a pad, really only the tips of our fingers move. When we use a large sheet of paper, our whole arm can move, and the whole thing opens up so much more expression.

I know not everyone has that kind of thing lying around, so you do you! Grab something, and let's get cracking.

Whatever you do, do NOT overthink this. I'm after an almost impulsive, spontaneous, gestural thing. So, be right off the cuff about it and just respond.

I'm going to give you a list of words. I want you to make a gestural mark for each word, conveying its emotion.

Count from three to one, and just respond to the following words as inspiration:

- Love
- Fear
- Joy
- Apathy
- Lust
- Hope
- Hopelessness

Without overthinking things, make some impulsive gestural marks that convey emotions.

Draw a self-portrait with a different colour pen in each hand, moving both hands at the same time.

Great! Well done. That should have loosened you up a bit. Hopefully, you get a sense of how you react to words, and, perhaps, even the marks you made convey a sense of each feeling or emotion.

Let's take things a bit further. This next exercise is inspired by Johannes Itten and is exactly the kind of thing he'd have you getting up to in his drawing classes.

TWO HANDS ARE BETTER THAN ONE.

You're going to need a sheet of paper, two pens or pencils (ideally different colours), and a mirror.

1. Fold your sheet of paper in half and draw a line down the middle.
2. Next, I'm going to have you draw a self-portrait. Don't worry if you're rubbish at drawing, just focus on the main shapes: the head is an oval, and the eyes are, too.

3. Take both pens or pencils and start to draw with both hands at the same time, trying your best to capture the shape of your head on the paper.
4. Focus on the balance between the left and right sides. This can become almost meditative or mechanical as the hands start to mirror one another.
5. Once you've drawn the main shapes, add detail, working in the hair and the ears, eyebrows, lips. Just make sure that whatever the left hand does, the right hand does, too, at the same time!

This will be hard—that's the point. There's every chance this won't look brilliant, either, but don't beat yourself up about that; you are simply getting your body in sync with your mind. There was a huge thing at the Bauhaus about the brain, and there's actually some pretty hard science around how exercises like this start to sync up the left and right hemispheres of the brain. Let's not get into all that now, just know it's useful and it works.

This is Grünewald's *Isenheim Altarpiece* from 1516.

THE SHAPE OF THINGS TO COME.

This is inspired by some of the stuff Josef Albers (German, 1888–1976) would get up to with his students.

You will need some tracing paper, or some thin paper, or even a drawing tablet. You'll also need a pen, pencil, or some charcoal. And scissors.

1. Look at Matthias Grünewald's (German, c. 1475/1480–1528) *Isenheim Altarpiece*.
2. Using only rectangles, triangles, or squares, trace the main shapes over it.
3. Now, redraw those main shapes onto a separate piece of paper.
4. With your scissors, cut out the shapes.
5. Look at all the amazing building blocks you've made for your work.
6. Start to arrange those items to portray the idea of:
 • Balance
 • Dynamic
 • Static
7. Photograph your Balanced, Dynamic, and Static layouts as you go. You don't want to forget them.

On tracing paper, trace shapes using only rectangles, circles, and squares.

Ask Yourself

Grab your notebook or journal and write a few lines about the following as a way to reflect on what you've been making.

- Can simple marks really capture emotion?

- Would someone else be able to look at the marks and guess the emotion you were trying to capture?

- What is it about combining shapes that can make them feel balanced?

- How is feeing balanced different from something that feels dynamic?

- What different feelings did I have in my left and right hands as I drew?

Isn't it amazing how the same simple formal shapes can create compositions that feel so radically different from one another? I love this so much; it just seems to conjure such inspiring shapes and designs. I hope you enjoyed it and it gave you a sense of the way simple building blocks make up our visual world. These shapes and patterns underpin so much of the Bauhaus, and focusing on their simplicity can help us make things with an economy and a balance that really works.

PICTURE THE POSSIBILITIES.

Let's daydream a little bit. Looking back over those collections of shapes, can you start to make out forms that could be things? Can you see something that would make a wonderful teapot, a coffee cup, a table, bird feeder, or a piece of furniture? Maybe you can see a clever grid that would make an amazing guideline for a poster.

Cut out the shapes you made and rearrange them, then take a photo of the finished compositions.

SCAN TO VIEW AN EXCLUSIVE VIDEO FROM STUART!

SITUATIONS

SITU

ATIONS

What if the world we see is n the real world but the world are conditioned to see?

...ink-ass renegades who ...ted nothing other than to ...age the world. Their goal was ...ake everyday life marvellous, ...xpected, and ecstatic.

SITUATIONS

SITU ATIONS

HOW TO INSULT A USELESS GENERATION.

The Situationists were a group of punk-ass renegades who wanted nothing other than to change the world. Their goal was to make everyday life marvellous, unexpected, and ecstatic. Right up until 1972, they published books, put on exhibitions, made films, and engaged in street art, including graffiti.

What if the world we see is not the real world but the world we are conditioned to see? The Situationist agenda was to explain how the nightmare works so everyone could wake up.

THE SITUATION

It feels like time to talk to you about Situationism. What's not to like about a little bit of youthful revolt and positive rebellion? From the clutches of postwar consumerism, a flicker of liberation came in the shape of artists and writers ready to create situations in which real life could be lived.

If we want to make work about the world we are in, we need to understand it, and although the Situationists booted off in the 1950s, their thoughts and ideas are still relevant to this moment right now.

The Second World War had ended and peace felt like it was here to stay. Europe was gripped with consumerism. Suddenly, people from all walks of life had access to consumer goods from all over the world, like cars, toys, electric irons, and TVs.

In 1957, in a small, picturesque village in Italy called Cosio di Arroscia, a group of artists and thinkers assembled. I won't go into the weird and wonderful avant-garde art movements they migrated from. Just know they were brilliant thinkers, from all sectors of life and the arts. They declared themselves the Situationist International and decided that all wasn't well in consumer-ville.

Their unofficial leader was Guy Debord (French, 1931–1994)—more on him later—but Asger Jorn (Scandinavian, 1914–1973), Constant Nieuwenhuys (Dutch, 1920–2005), and Giuseppe Pinot-Gallizio (Italian, 1902–1964) also played a huge role.

"Sous les pavés, la plage!" ("Under the pavement, the beach!")

BOREDOM IN CONSUMER-VILLE.

The Situationists believed society arranged around consumerism would lead to a special kind of boredom that could only be satisfied through purchasing products.

Essentially, what they were getting at was the idea that working nine to five to make your boss rich would make you fed up, and that opened the doors to clever and tricky advertising that convinced us that the way to fix the problem and get the satisfaction we craved was to buy things like cars, fridges, and Hoovers.

So, the Situationists set out to disrupt this routine with art. They'd make it their modus operandi to create situations where this capitalist monotony was hijacked without people having to buy anything. Instead, it was about people actually experiencing real moments, moments that were truthful and very different from the popular lie being touted by big business and the ad men of the age.

BUT HOW?

The Situationists had a couple of techniques up their sleeves for this. A big one was the "dérive"—or "the drift"—which was the idea that as someone walked through the city they could be sucked into experiences that were good, or repelled by the things that were bad. The point was, the city itself, with its streets and buildings, ebbs and flows, could help people see the world in an entirely new way.

To implement this technique, they created maps. The environment you occupy has an impact on how you think and how you feel, and the way you move through that environment makes a huge difference in your experience, emotions, and behaviour. They called that "psychogeography."

The other big idea was "détournement," or creating hybrid things out of what is already there—subverting them and changing them, even degrading them. They refused to do anything original; that was old hat. Using what was already there was a lot more interesting because they could pull things together that didn't

Back in 1967, *The Society of the Spectacle* was the unofficial manifesto for Situationism. Today, Guy Debord's words seem more relevant than ever.

belong together and create an uneasy tension. That all came together in the book *Mémoires* by Guy Debord and Asger Jorn. It shows détournements in the form of collaged maps, photographs, advertisements, and cartoons. Through its map-like pages, we get a sense of people moving through the city, and a feeling that they are experiencing it in a totally new way.

Situationist ideas were pivotal in detonating the 1968 student revolt in Paris. Many of the protestors waved placards emblazoned with Situationist slogans. As the youth tore up the streets, building barricades from paving slabs, they discovered sand. Before long, anonymous graffiti started to appear. The phrase "Sous les pavés, la plage!" ("Under the pavement, the beach!") became a rallying cry for an entire generation.

THE TIME FOR ART IS OVER.

One of the most important works to come out of the movement was Guy Debord's book *The Society of the Spectacle*. Whilst not really a piece of visual art, it's a vital piece in many ways, being more of a manifesto than anything else. In it, Debord is not only helping us see behind the veil of this new consumer society, but he's also encouraging and inspiring us to do something about it.

Asger Jorn painted over kitsch second-hand paintings, détourning them by adding extra brushstrokes.

Debord explains that images and appearances have become more important than actual experiences or real truth.

When all our basic needs are met, and technology makes it easier to live, in order for capitalism to continue, it needs to move the needle on what we need. It needs for us to think we need way more than we actually do. These consumer goods become less of a want and more of a false need. He tells us that the images we see reinforce this idea.

The clincher here—and the reason this makes so much sense in the times we are in now—is this idea that, in the back of our mind, somewhere, we believe having these things will make us appear better in the eyes of others. So, we need them for prestige, not for the function they actually perform.

Of course, so much advertising does just that: It shows us images of what buying something says about us, how it will make us feel, rather than what the thing actually does. These images are way more about our identity than they are about the usefulness of the product. Debord calls that "the image world," and he urges us, as artists, to challenge it.

Meanwhile, in Paris, Asger Jorn's exhibition shook things up further. He took second-hand kitsch paintings and painted over them. Winding up the establishment by telling them that painting was over, so why not just bring it up to date with a few extra brush strokes? His deliberately crude or bad paintings were his way of détourning and modifying the past.

SELLING IT BY THE METRE.

Meanwhile, Giuseppe Pinot-Gallizio made abstract paintings with his "painting machine," which used long mechanical rollers to create paintings up to 145 metres (158.5 yards) long. Although mass-produced, the paintings were gestural, energetic, and completely unique. He rolled them up to store them. The light blue and green, yellow, bright pink, and black colours only became visible as the work was unrolled from a spool. It was kind of like a journey. They could drape down the walls of galleries or along the floor. Mocking the art market further, he sold his work by the metre at the street market in Alba or at commercial galleries themselves.

This whole thing made a huge impression on me and, at a time when our personas are constructed on social media, I think the ideas are more relevant than ever. Let's look at some of the works I've made that have a decidedly Situationist backbone.

Giuseppe Pinot-Gallizio's industrial painting turned the commercial artworld upside-down by flogging his work by the metre.

THESE IMAGES ARE WAY MORE ABOUT OUR IDENTITY THAN THEY ARE ABOUT THE USEFULNESS OF THE PRODUCT.

MY SITU ATION

Visitors watch assistants de-objectify Stuart's painting at his *D.A.B.A.* project in London, 2023

I was born in England in the 1980s, into a working-class family at a time when "greed was good" and the barrier between the haves and the have-nots was brutal. The coal mines were walled by picket lines, and whole communities evaporated due to their closure. Duran Duran were sunning themselves on yachts in music videos and, in my house, the only escapism was music. And that music was about as Situationist as it came: It looked like punk rock, tasted like punk rock, and felt like it, too.

I knew, at that point, art was my ticket out of there. I got the message that there was another way through and it wouldn't be as a nine-to-five person working for "the man." I quickly learned that making stuff and expressing myself was a reward in itself—something nobody could police and nobody could control. I told you before—daydreaming is free. For some of us, it's all we have.

Living as an artist was about as "situationist" as it can get; it is, in itself, an act of total rebellion. The world we are in is not optimised for creativity; in fact, creativity is often punished. I want you to realise, more than anything, that outside the bubble of well-behaved, prescriptive, nine-to-five working and buying, there's something else, and that something is freedom.

Stuart Semple, *D.A.B.A.: Tools for mass de-objectification*, 2023

DESTROY ALL BAD ART.

Those early ideas of expressing things, outside of what is conventional, and Situationist ideals, fuel so much of what I've made—not least of which is *D.A.B.A.* or Destroy All Bad Art. What I mean by "bad art" is objects that aren't really art. Of course, what's good or bad is entirely subjective. The point is, real freedom looks like the ability to question that idea. To understand that art is an experience, a way of being, not an object that can be traded.

So, I opened a show in central London in 2023, and I invited anyone who fancied it to bring an object that, to them, was "bad art." They brought prints, posters, books, records, and ornaments. They submitted the objects to an Office of De-objectification, where they were then destroyed by a team armed with golf clubs, saws, angle grinders, knives, and baseball bats. The objects were reduced to a powder or B. A. P. (bad art pigment). Meanwhile, in a back room set up as a lab, there was a team of art conservators, slowly dismantling several of my paintings, reducing them to their basic materials and archiving the elements—"bent staple," "cotton canvas fragment," "pink pigment"—in little scientific vials. I wanted to raise the question of the value of art objects. Annoyingly, as people bought the relics, we realised, financially, my work was worth more destroyed.

*To understand tha
experience, a way o
that can*

MY SITUATION

Stuart Semple, *ENGLAND*, 2017

SELLING ENGLAND BY THE POUND.

I've always had an obsession with consumer goods, just like the Situationists, and I wanted to challenge the idea of that, to prove that nobody really needs most of this stuff we buy. So, I decided to take it to the extreme and sell England on the internet. I got 100 percent pure British soil and packaged it to look like a luxury perfume. I then sold it by the pound (454 grams)—the idea being that if I could get people to buy mud, it would show just how ridiculous consumerism is. And they did buy it (!), proving that if you make something look attractive enough, it will sell. (I will, however, never know if people saw it as a joke or if they bought it as a piece of art.)

We know that Situationism is more of a way of being than a certain type of artwork. That reality plays out in my work in almost spontaneous performances, such as the Mullet Meet—a pro-mullet march I organised. As you've seen previously, I like to reverse the idea of a protest to make it positive. I yearned for a weird

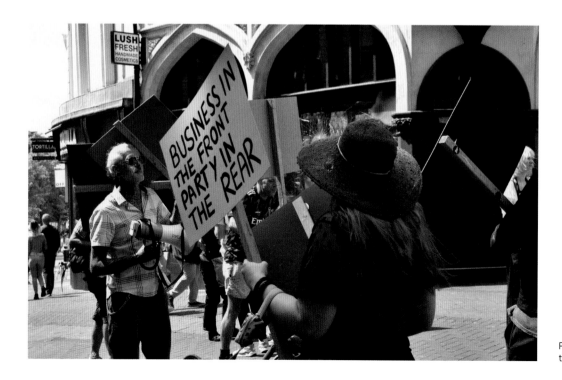

Protestors celebrate the mullet hairstyle.

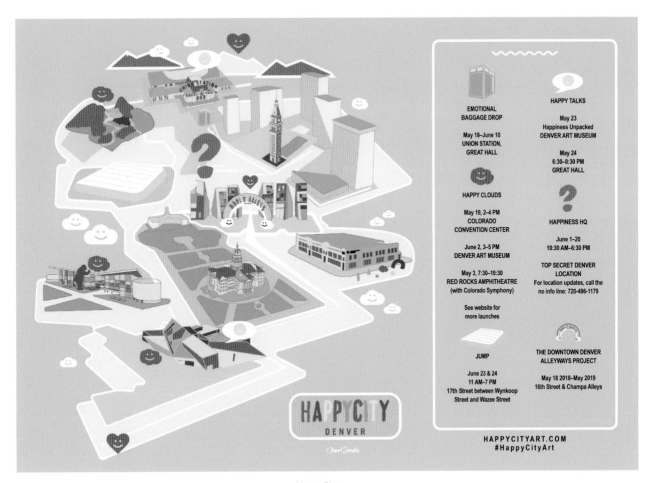

HappyCity map.

absurdity, so in the Mullet Meet, people marched to advocate for the "business in the front, party in the back" hairstyle.

I love doing things like these marches because they disrupt the flow around public spaces. These kinds of processions invite people to join them, and they change the feel of the environment.

You can see that idea demonstrated in the HappyCity map I made for Denver. We gave out thousands and thousands of maps, and they pointed to places of delight, areas that people might take for granted. I hoped they'd give people another perspective on the city. Of course, I also built things around the city for them to find, but mapping it was an important part of the whole experience.

Getting out of the gallery and outside the system is a powerful place to play. When we do that, we open up the potential to signpost a way out of mundane life for other people. That's really the point of making work, creating these tiny cracks in life where people can discover meaning. As an artist, there's nothing more important that you could be doing.

Let's try a few arty exercises together that can help you bring some of these Situationist ideas into your way of making work.

THAT'S REALLY THE P
WORK, CREATING THESE TINY
WHERE PEOPLE CAN DIS

YOUR SITUATION

It's your turn to get busy and make some stuff in response to things you've learned so far about Situationism. Before we pop the bubble of "the spectacle," let's start by loosening up a bit.

Clear your mind, totally relax, and let your hand move wherever it likes. Keep going until it feels like the drawing is making itself automatically.

AUTOMATIC FOR THE PEOPLE.

A big thing the Situationists did was automatic drawing. Today, we want to use it to loosen up and get into a creative flow where inspiration is a lot more likely to occur. This means letting the drawing happen almost all by itself, getting your rational brain out of the way, and letting the subconscious find its way through. It's a lot easier than it sounds, and this process can provide some incredible insight and inspiration that you might struggle to find otherwise. The idea is to relax the mind and see what happens.

1. Grab a pen or a pencil and some paper.
2. Make your mind as blank as you can, have no idea whatsoever of what will happen on the paper. Just trust it will.
3. Take the pen and invite your hand to start moving. It can go wherever it likes.
4. Now, continue doodling like this, whatever comes, just comes.
5. At some point, your mind will really relax and you'll enter a state where the drawing makes itself.

CATCH MY DRIFT.

Let's do a bit of mapping together. This is always fun.

There are a couple of ways to do this mapping but, by far, the best way is to go out into your neighbourhood for a walk. I'm aware not everyone will have the ability to do this, so use Google maps as an alternative. Online, you can take a stroll through any major capital city. Paris or New York is always fun online.

1. Grab a sketchbook or some paper and your camera phone or a real camera.
2. Plan how long you want to be out: Fifteen minutes? Thirty minutes? One hour?
3. It's vitally important that you not have any premeditated idea of your route, though. Surrender yourself to the process of letting the environment either pull you in or repel you.
4. Now, go explore—online or in the real world.
5. As you start your journey, be open to what is pulling you in; if you find something doing that, photograph it or make a little sketch of it.
6. If you find something repelling, you do the same.

YOUR SITUATION

Go out and explore. Photograph what seems to pull you in, and what pushes you away. Compile your photos into a map—make it an artwork in its own right.

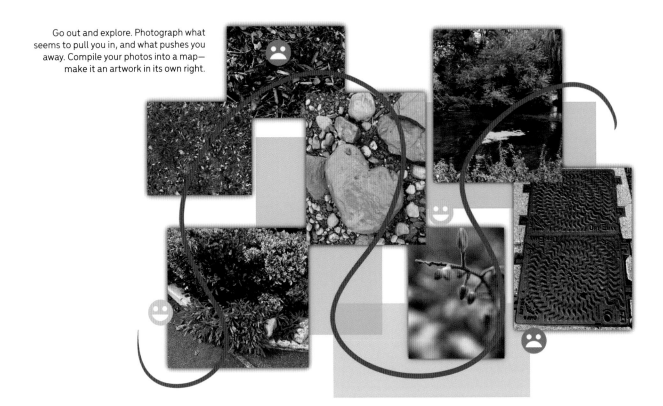

7. Carry on documenting your journey through the things that pull you in or push you away. Let those things dictate your route, where you go next. Be as passive as possible in the process. You are looking to surprise yourself.
8. When you're done, go home and compile your route into a map, perhaps as a collage that shows where you went and what you saw. Make it an artwork in its own right.
9. Bonus points: Give that map to a friend and send them out there with it. Have a good chat with them when they get back. There's so much you can learn from that conversation.

Hopefully, you saw the world around you in a new way and found some moments of intrigue that, perhaps, would otherwise have been easy to take for granted.

INSULT YOUR GENERATION.

Before we dive into this one, I want to put a quote in your mind. It comes from Malcolm McLaren (English, 1946–2010), who, if you don't know, not only managed The Sex Pistols, but he also pretty much started punk, and a huge part of his inspiration was Situationist ideas.

McLaren said, "Terrorize, threaten, and insult your own useless generation."

To do that well you need to know what your generation is up to, analyse it a bit, and then replay its stupidity back to itself using art. It's not as hard as it sounds. I'm sure there are loads of things about your generation you find a bit silly or useless or that you don't agree with.

Get a magazine—I typically like to use fashion or style mags.

3. Marcel Duchamp drew a moustache on the *Mona Lisa*, and I'm sure most of us have drawn a moustache or glasses in a magazine before. This exercise is a bit like that, but we want its purpose to be more pointed, more of a message.

4. Draw or paint a slogan or phrase over the ad you've selected that speaks to the stupidity of your generation. The more insulting, the better, and the stronger the work will be.

That's it! Super simple, really. Détourne stuff by hijacking it; change the meaning or the environment around you by seeing how it feels, and don't forget to stick a finger up to stupidity. It's your job to provoke change.

1. Grab and pen and notebook. Take ten minutes to write a little list of those things about your generation that annoy you or you don't agree with.

2. Now, grab a magazine—ideally one with some advertisements in it. If you can't have a magazine, find images of advertisements online.

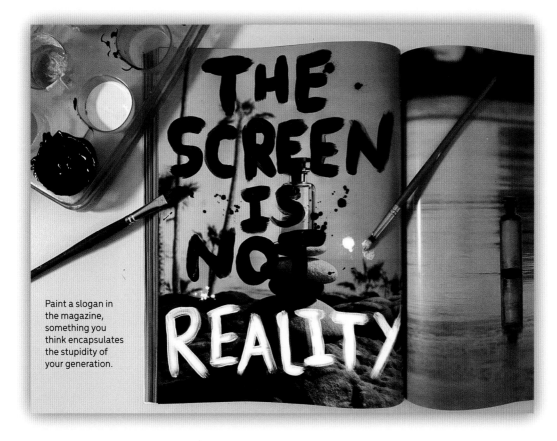

Paint a slogan in the magazine, something you think encapsulates the stupidity of your generation.

SCAN TO VIEW AN EXCLUSIVE VIDEO FROM STUART!

FLUX

is idea isn't about the
inished product but,
ather, about how you get
here—the process.

FLUX

FLUX

TOTAL ART MATCH-BOX

USE THESE MATCHS TO DES-
TROY ALL ART — MUSEUMS
ART LIBRARY'S — READY —
MADES POP — ART AND AS
I BEN SIGNED EVERYTHING
WORK OF ART — BURN —
ANYTHING — KEEP LAST
MATCH FOR THIS MATCH —

If your work can't touch an audience, then it dies at birth. That is exactly what Fluxus set out to resuscitate.

FLUX **FLUX** FLUX FLUX

MAKING ART FOR EVERYONE.

Your art is important because, when it touches people
it changes them—the enemy is elitism, that "old boys'
club" where the wealthy, educated, Old-World power
systems dupe us into thinking lesser mortals don't have
the capacity to understand it. If your work can't touch
an audience, then it dies at birth. That is exactly what
Fluxus set out to resuscitate. Let's have a look at how
a group of artists orbiting around the idea that "art
should be for everyone" totally transformed the cultural
landscape forever.

A STATE OF FLUX

My art college bussed us to London—the big city. At that time, the big street in the big city for art was Cork Street. Each side of the street was lined with commercial galleries, flanked by Rolls-Royces and Bentleys, their drivers waiting patiently for their bosses to return with the spoils of their latest art acquisition.

I, on the other hand, was scruffy: ripped jeans, KLF T-shirt, and a '90s Brit-pop hair flop that made me look less secret rockstar grunger and more scruffy street urchin.

I leaned in to get a closer look at a painting—I needed to see how this thing was made. Suddenly a foghorn-like voice reverberated around the space: "Get your filthy hands off my wall." The blood rushed to my acne-scarred face and my first sense of a place not being for me stung with the kind of humiliation a scolded child holds on to for a lifetime.

This is why I love Fluxus, the most democratic art movement ever. The core of it is the idea that art should be for everyone. No elitism, no gatekeepers. Nobody was left out in the cold. As the most radical and experimental movement of the 1960s, the Fluxus message means the world to me—because almost everything I do is an attempt to demystify art, giving access to it to as many people as possible.

USE WHAT YOU'VE GOT.

This idea isn't about the finished product but, rather, about how you get there—the process. Keeping things simple. Fluxus is more of a way of life than a particular style or set of rules. In fact, most of the work was made with whatever was to hand. It could be a party, a postage stamp, furniture, a wedding, a divorce, protests, clinics, tattoos, chess, or even an island.

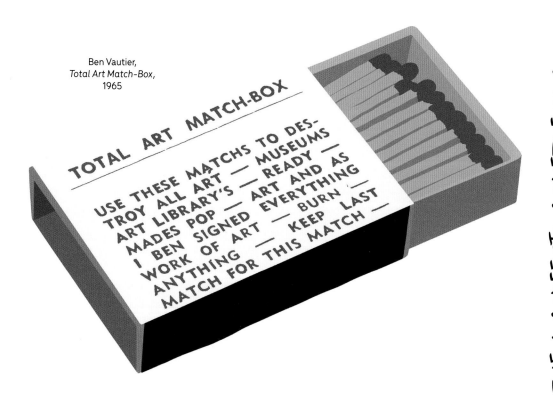

Ben Vautier,
Total Art Match-Box,
1965

THE MANIFESTO ASKED FOR A REVOLUTIONARY FLOOD IN ART. AN ART THAT WOULD BE AVAILABLE FOR EVERYBODY, NOT JUST CRITICS AND PROFESSIONALS.

Joseph Beuys, *How to Explain Pictures to a Dead Hare*, 1965
For his first solo exhibition in a private gallery, Beuys presented his best-known action: Viewers witnessed
the artist whisper to a dead animal whilst he was covered with honey and gold leaf.

CAGE STARTED IT.

To get your head around this, we need to start with
John Cage (American, 1912–1992). He was a brilliant
composer and he had a huge influence on Fluxus. He
was teaching at the New School for Social Research in
New York in the 1950s and '60s, where his ideas touched
many of the artists who would take on Fluxus ideas. His
big thing was starting a work without having an idea of
where it would end. He really felt that the work was a
place for the audience and the artist to connect.

ANTI-ART.

However, it was George Maciunas who coined the
term "Fluxus" in 1960, after his New York gallery on
Madison Avenue closed due to debt. He went to West
Germany to do graphic design for the Air Force and
wanted to keep the art side going, so he started to
make publications. Maciunas didn't want these yearly
collections of what was going on to feel like the past,
so he binned ideas of old movements and called the
publication *Fluxus*. He wrote the Fluxus Manifesto in
1963 and called for an end to all intellectual, bourgeois
ideas. The manifesto asked for a revolutionary flood in
art, an anti-art that would be available for everybody,
not just critics and professionals. He wanted artists to
unite as a force to be reckoned with.

Fluxus was never really a movement in the truest sense of the term; it was just a set of overlapping ideas that various artists and groups orbited around. The closest anyone really got to defining it was as a laboratory. What matters right now is how we can draw inspiration from the freedom it produced. Like nothing else, it opened up what could be considered art; it takes Duchamp's urinal and transforms it into an interstellar toilet on hyperspace steroids.

I love so much of the work, but it is the concept of mail art that really empowered me. The concept: Regular people can mail-order art and have it delivered to their homes. The humble post office, in the hands of these artists, became a way to distribute art and ideas to everyday people. Mail held, for many, a unique power to "deliver" art to one's doorstep, into the sphere of everyday life. One of Cage's pupils, Dick Higgins (American, 1938–1998), put it like this: "Give us this day our daily surprise." To me, that's so beautiful and so powerful. In the time of the internet and webstores, how easy is it to send anything to anyone anywhere, affordably?

SPECIAL DELIVERY.

Maciunas put together yearly art boxes that contained all sorts of objects by artists and that you could order to be delivered to you. Probably my favourite work was in Art Box Year Two: *Total Art Match-Box* by Ben Vautier (French, born 1935). It's a total provocation in which he calls for the destruction of everything that was classed as art and then asks us to destroy the box of matches itself. What an amazing way to remove everything except an idea. It was a massive inspiration in my *D.A.B.A.* project I mentioned in the last chapter. If we take away the object, all we are left with is art itself. Beautiful!

This sense of humour in the works is such a unifying feature. Maciunas himself said, "Art is a joke."

Nam June Paik (Korean American, 1932–2006) is on stage, axe in hand, smashing a piano to smithereens. The audience ponders the sacredness of objects as they see tradition vanish in front of their eyes. In this work *Zen for Head*, we bin that boring old notion that artists need to be skilful, instead let's celebrate the messy and the noisy.

Then in 1965, Joseph Beuys (German, 1921–1986) covered his head in honey and gold leaf whilst whispering a monologue to a dead hare. He quietly explained his drawings and artworks, calling it *How to Explain Pictures to a Dead Hare*. To me, it's a deep reflection on communication and the interconnectedness of all things. He's challenging us all to think about the role of art in the world.

Another brilliant piece, which uses one of the most readily available materials on the planet is *Three Aqueous Events* by George Brecht (American, 1926–2008). It's a very simple idea with clear instructions such as: "Sprinkle: distilled water" or "Leak: spring water." I think it makes us question the everyday things we do in new ways.

Perhaps Nam June Paik managed to sum it up better than anyone else: "Fluxus is simplicity. But it's not just an object or a painting. It's an attitude towards life." Let's have a look at how that attitude has influenced my life and some of the things I've made.

"Fluxus is simplicity. But it's not just an object or a painting. It's an attitude towards life."

THREE AQUEOUS EVENTS

- ● ice

- ● water

- ● steam

Summer, 1961

George Brecht, *Three Aqueous Events*, 1963
Brecht's instructions for *Three Aqueous Events* were printed on cards and made as part of
a boxed set of sixty-eight other works that George Maciunas produced.

I FLUXED IT UP

I FLUXED IT UP

There's something so democratic about art making its way into everyday people's homes. It blows my mind that the artists of the 1960s were thinking about that, long before we were all used to shopping for everything on the internet and taking for granted the fact it would get to us.

Whilst in my twenties, I developed an unhealthy obsession with indie record labels and would find myself patiently waiting by the door for a new release by my favourite band to arrive. I loved everything about the records and the stickers and, sometimes, the posters I got with them. These things, to me, were artworks, and in most cases, had actually been assembled by the artists themselves in their spare bedrooms.

After my near-death experience, with a terrifying anxiety disorder raging, I started making work every day. I needed to cope and I needed a platform to get out my emotions.

Those works were powerful therapy. I signed them "Nancyboy," not really ready to step into my own identity and hoping to keep a little bit of emotional distance between the real me and what I was going through. In those days, I didn't know any galleries, and there was nobody willing to give me a platform for my weird angsty visual rants. There was no social media, no blogs, no sign of Facebook, let alone Myspace. The only place you could really upload an image was the auction site eBay. So, as part of this process, I'd spend all morning in the bookshop, reading and collecting images by stealthily photographing pages from style mags that I couldn't afford to buy. Then, I'd go home to a small rental flat opposite a milk shake parlour. I covered the walls of a tiny spare bedroom with cardboard I found in the trash (my way of protecting it and not getting in trouble with the landlord).

So, as part of this process, I'd spen. all morning in the bookshop, reading and collecting images by stealthily ...ching pages from style mag.

As a teenager, I distributed thousands of my anxiety drawings on eBay. Here are a few examples.

MAIL ORDER MAGIC.

I'd paint all afternoon, trying to fathom why I couldn't swallow or walk down the street without clutching at lampposts, hoping to get an inkling into why I was calling the ambulance several times a week, feeling like my heart was in my throat. Every evening I'd upload three pictures to eBay, no reserve, starting bid just £2 ($2.44). It was a daily ritual. Now, a lot of people talk about this ten thousand hours thing. And the argument is that the Beatles went over to Hamburg, played all day and all night and came back as awesome musicians. I don't know if it's true, but over the next three years, I made and sold more than three thousand original artworks on eBay. People from all over the world were collecting my things. Always indie, never selling for more than about £100 ($122), I'd send them to people with little special multiples—a bag of Lucky Salt or a postcard I'd doodled on. This was the start of mail-order art in the digital age.

I fell in love with this process from the start, the accessibility and the democracy of it. My payment was the therapy, a problem shared is a problem halved, after all. With all those people around the world parting with their hard-earned money for my things, for the first time in a long time, I didn't feel so alone.

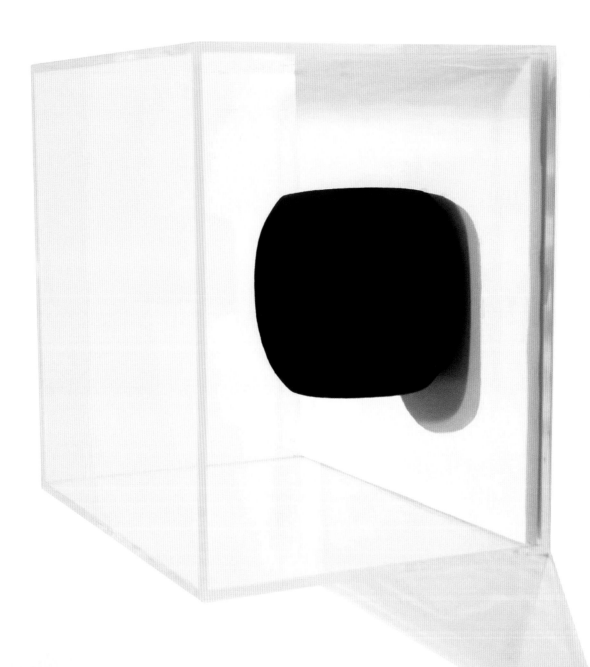

Stuart Semple,
Biennale in a Box,
2022

Of course, we've now seen that musicians have direct relationships with their fans, and no need of a record label, thanks to the internet. Finally now, with platforms like Instagram, visual artists are forging connections with those who enjoy their work, without the whole rigmarole of a commercial art world. I'm not knocking the gallery system, I'm just saying that technology has enabled us to have direct relationships, too.

Sending things to people via the mail is brilliant—there's nothing more direct than that and it's something that goes on all day long in my life. You can buy things from my studio on my website, not just paint that we make but also artworks and multiples. One of them is called *Biennale in a Box*; it's a small Perspex (acrylic) box, with a die inside painted the blackest black.

Anish Kapoor (British Indian, born 1954) did a show at the Venice Biennale with all these objects he'd coated in this super-black paint. Few people could afford to go to Venice, and even fewer would feel comfortable at a big art opening at a palazzo. So, to make that experience totally accessible to everyone, I sent my very own Biennale to anyone who wanted one. Right now, from that, a few hundred people have something I made, and that's a really lovely feeling.

Finally now, with platforms like Instagram, visual artists are forging connections with those who enjoy their work,

Groups from all over the world joined *Joy Sandwich*, making towers of jam sandwiches together. Photo courtesy Gallery Nostrum, Belgium

ART IS OVER.

Of course, by now you know how much I love John and Yoko, and what they did. A lot of people don't agree with me, and think the idea of planting acorns or staying in bed is a bit stupid, if not attention-seeking. For me, there's something in it. And they really made an impact, to the point where I actually appropriated their song "War Is Over" and turned it into *Art Is Over* and plastered it all over London. That might be the most direct Fluxus homage in what I've done, but the wider ideas are a conduit that runs through most of the work.

Take *Joy Sandwich*, for example, a simple set of instructions distributed via the internet. I wanted to use this age of mass communication to make something happen all over the world. So, I put up an Instagram post asking arts groups, museums, and arts centres to collaborate with me. Hundreds wrote back—art shops, coffee shops, and even people with big backyards who wanted to get involved. I wanted

to make something that didn't need money and didn't look like art. I told people to share jam sandwiches with each other, and if they couldn't bring bread or jam they could join in anyway.

The game was easy: Spread some jam on bread whilst saying out loud what you are grateful for, then the next person would do the same, adding their jammy slice of bread on top of the previous person's. In the end, jam towers were built all over the world—from Mexico City to the Philippines, across Canada, the United States, and into Europe. It was marvellous. It ended when the tower fell and everyone ate together. Beautiful, but totally impossible without Fluxus.

Now it's your turn. Let's see how you can use Fluxus ideas to make art out of almost nothing, and how you can distribute your ideas to people all over the world, too.

(Opposite) Photo courtesy Open Space Art Gallery, Ottawa

HOW YOU CAN FLUX STUFF UP

The Fluxus perspective is much more of a state of mind and a way of doing things than it is a particular set of exercises so it's hard to get practical with this one. Don't worry, though, I've got you. Let's focus on making some objects and getting them out there so you can start to build and connect with your audience.

Remember, the big idea is to create something that's available to everyone, accessible, and democratic. Something that's not just for critics or collectors. I thought it might be fun for you to help create a piece of my work, and actually disseminate it to the public.

MULTIPLY.

When I first started selling my work on eBay, I'd put a little signed item in each package I sent out, and one of those items was Lucky Salt. There's a rich history about the power of salt, and a kind of magic around it that I find fascinating, and there's something generous about sharing it. Just to be sure you've got the lingo, in art, when we make several of a similar kind of thing, we call it a "multiple." So, we're going to make some multiples.

You are going to need some paper, some tape or glue, a pen, and some salt. Let's get going.

Package It. Make some little envelopes for the salt:

Take a rectangle of paper, any size you want, (coloured paper is nice). Fold the top corners down till they touch, evenly.

Package it: Take a rectangle of paper and follow the steps to make your own envelope.

2

Fold the bottom up to join the bottom of the folded top parts.

3

Then do that again, but this time, fold the paper along the middle line of the top and bottom folded parts.

4

Fold and bring down the top corner. Make it join the bottom of the current pattern of folds. The two corners at the top will be the folding point for the sides.

5

Fold up your sides about 45 degrees and bring the top (flap) part of the envelope down again to where it was.

HOW YOU CAN FLUX STUFF UP

Finally, insert the extra (top-open) bits of the sides below the flap to close it.

Voilà! You now have your first envelope. Repeat until you have at least ten envelopes.

Multiply it: Make ten envelopes and write "Lucky Salt" on the front.

Let's Make It a Multiple. Make ten of the envelopes you made and write the phrase "Lucky Salt" on the front; you can decorate it however you like. On the back, number them 1/10, 2/10, 3/10, etc., and sign your name to them.

Let's Share Them. Make a photo of your work and post it on your social media. Let people know you are sharing your *Lucky Salt* artwork that you made in collaboration with Stuart Semple and, if they'd like one, they should message you. Let them know how much they cost (make it affordable) and that they'll need to pay for postage. Hopefully, someone bites and you actually get to mail your work to a real human somewhere in the world. Who knows? If I see it, I might even buy it!

Use the hashtags #LuckySalt and #makeartordietrying so we can all see it.

BONUS POINTS.

If you want to take this to the max and really get a sense of how you can share your work, consider listing your Lucky Salt on eBay, Etsy, or a similar platform. That's how I started, and it's incredible all the people you will get to meet.

If you do that, it's really important to make the title of the auction something people will be searching for. A good idea, and this is very cheeky (shhh, you didn't hear this from me), is something like "Original Signed Fluxus Art Object by [your name], not Yoko Ono." If you clocked that, you might have just received a little secret to get your work in front of a lot of people.

Have fun, and if this rocked your boat a bit, consider what other art multiples you could make and disseminate through the mail. If you are really into it, you might even set up a little webstore with a few different multiples for people to choose from, a bit like I have on my website. Honestly, there's no better feeling than when a complete stranger somewhere in the world receives your work in real life.

Share it: Now is the time to show the world what we've made together. Take a photo of your multiple and post it on social media. Don't forget to tag it #LuckySalt so the whole community can see it!

SCAN TO VIEW AN EXCLUSIVE VIDEO FROM STUART!

The thing is, ...
ence colour is link...
We all agree on wh...
red is, but in reali...
really know if we...
same thing.

COLOUR

COL OUR

Nothing really stirs our emotions the way colour can.

COLOUR

COL
OUR

COLOUR

A DIRECT LINE TO YOUR EMOTIONS.

Ever since I got a glimpse of Van Gogh's
(Dutch, 1853–1890) Sunflowers at the National Gallery
as a kid, I have been totally and utterly obsessed with
the power of colour, whose history is a wild ride of
espionage, ground-up mummies, black square, white
paintings, and epic battles. Nothing really stirs our
emotions the way colour can. And, in the right hands,
artists across the ages have wielded it to transform the
very way we look at the world around us.

A COLOURFUL PAST

Did you know that up until the 1500s we didn't even have a word for the colour blue? It was like it didn't exist. In the times of the ancient Greeks, Homer described the sea as wine-coloured for want of a better word. It wasn't just the Greeks, though. In the Koran, early Hebrew Bible, Vedic humans, and ancient Chinese stories, even though other colours are there, it's as if blue simply doesn't exist.

The thing is, the way we experience colour is linked to language. We all agree on what the colour red is, but in reality, we don't really know if we all see the same thing. Scientists have proven it by finding Indigenous cultures that seem to be able to spot differences in colours, and name them—no matter how many times they mix up the colours. When the same colour swatches are shown to Western university students, they all look the same and they can't possibly tell one from the other. The only difference: the Indigenous People had words for the different colours that we didn't.

IT'S THE EXPANSE OF LIMITLESS SPACE. THE PLACE WHERE THE DARKER EMOTIONS HIDE.

Kazimir Malevich, *Black Square*, 1913
Malevich declared a whole new era for art by abandoning paintings of objects all together.
His *Black Square* painting was an entirely new art object in itself.

We all know that nature makes the best colours; we only have to walk through a meadow on a summer day to be totally captivated by the incredible array, or to look at a sunset to feel a state of awe. Artists have always been driven to capture those scenes. In the old days, they'd do everything they could to get their hands on incredible pigments from all over the world, often Venice or India, to use in their work. These colours would travel along the Silk Road and "colour men" would sell them to artists' studios like magic potions from far-off lands. Some of these colours were so precious that the result was like the Hollywood special effect of the age and would elevate the artwork to new heights. In these artists' studios, their assistants were busy making the colours according to their secret recipes and storing them in pig bladders until the painters needed them.

Later on, paints became commercialised, mainly because artists invented the tube. We all take it for granted—we get our toothpaste in it—but the humble tube originated in the artist's studio. The best stuff was expensive. One of the reasons Van Gogh's paintings stand the test of time was that his brother Theo really splashed out on those colours he sent him. The pure cadmium in his oranges, yellows, and reds came together to make some of the most joyous works the world has ever seen.

NONE MORE BLACK.

Black is one of those colours that has seduced artists for centuries. It's the colour of the otherworld, the nighttime realm. It's the expanse of limitless space. The place where the darker emotions hide. In fashion, it's sophisticated and luxurious. It feels elegant and refined. Artists such as Caravaggio (Italian, 1571–1610) embraced black's capacity to make things emerge from the shadows.

Other artists, such as Kazimir Malevich (Russian, 1879–1935), questioned black's very nature. Let's dive back to 1915 Russia and take a look at Malevich's *Black Square*. At the time, he was trying to break away from stuff that looked like other stuff and hoped to find a new kind of abstraction.

Black Square is, basically, a perfectly painted black square slap bang in the middle of a canvas. To him, it was way more than that, though, representing a kind of zero point of form and colour, a space where almost anything could emerge. He was trying to use something visual as a sort of language that didn't need anything recognisable to make sense. The square became an open portal to a place where emotions, ideas, and spirituality could meet.

Anish Kapoor, *Descent into Limbo*, 1992
Kapoor's hole in the floor of a gallery looked so flat that a poor bloke fell into it in Portugal.

Yves Klein, Blue
International Klein Blue is probably one of the most famous colours to have
ever been created by an artist.

KAPOOR BEHAVIOUR.

More recently, Sir Anish Kapoor's obsessions with voids and the abyss led him to make an exclusive agreement to own the blackest black. In 2016, he made a deal with a British nanotech company to be the only artist allowed to use their new super-black material. This stuff is so black it's as if all light is absorbed by it—it makes 3D things look almost flat, or like they've been Photoshopped out of real life. It works by creating a microscopic forest of carbon nanotubes that trap light inside, letting hardly any out again.

One of Kapoor's most famous works dealing with the abyss of black is *Descent into Limbo*, an actual hole made in the floor of a gallery that is painted all black inside. Strangely, in real life, it has the effect of looking almost like a flat black circle. Sadly, though, when the work was installed in Portugal, someone fell into the hole and ended up in hospital. The poor bloke literally descended into the void.

Now, let's look at one of my favourites, a huge inspiration for me in so many ways, Yves Klein. The way this man's mind worked is unbelievable.

I want to focus on a colour he created, well more of a paint than a colour. It was a rich ultramarine blue acrylic paint that dried almost powdery and ridiculously blue. If you see it, you feel like it could suck you in. He called it IKB, International Klein Blue, and he patented it as it was so integral to his work. He used it in loads of paintings. He described it as "the blue sky, which seems to devour everything, to engulf everything. It has monumental tranquility."

He described it as "the bl sky, which seems to devou everything, to engulf ever ...tal tran

Robert Rauschenberg, *White Painting*, 1951
Rauschenberg's all-white paintings are less about the painting and more about the
space around them. The white reflects light and picks up shadows.

One of Klein's most famous series is the *Anthropometry* performances, in which he directed nude models covered in IKB paint to imprint their bodies on canvas, creating living human paintbrushes. These actions followed his idea that the human presence is an extension of the infinite blue, merging the physical and the metaphysical.

DRAWING A BLANK.

No whistle-stop tour of artists exploring colour would be complete without transporting you to the other end of the tonal spectrum. We can't have the deepest blacks without the purest whites. For that, we need Robert Rauschenberg, and we need to pop back to New York in the early 1950s where, for a couple of years, Rauschenberg made all-white paintings. I mean completely white, and at a time when bright, bold, splashy, abstract paintings were about to make way for a cooler more considered minimal conceptual art.

He didn't want a painting to depict something else; he didn't even want it to be some weird holder for the artist's emotions. He was after something that had no emotion, no personal expression, something entirely neutral. Looking at one of these paintings becomes an experience where we have to look inside ourselves to hunt for how we feel about the missing meaning.

Whether it's the psychology of colour, where we are hardwired to avoid red and yellow things because they remind us of the way nature can sting, or a way to convey emotion in our work, or even make something feel more desirable or luxurious, colour is a tool we can use to make work that makes an impact.

COOK ING UP COLOUR

COOKING UP COLOUR

The kitchen is a wreck. Cooking oil, chopped-up beetroot staining the work surface, and turmeric on the floor. My grandmother is annoyed, very annoyed. I'm about four or five and I'm making paint. She has a bad print of a good Van Gogh above her bed, a riot of colour in a cornfield. I need to recreate it with the wrong end of a knitting needle and my beetroot and turmeric concoction.

Sadly, or maybe thankfully, I never had money for materials so I made my own.

A few years later, I'm in the garden shed, and I've got bags of pigment, probably so toxic my lungs will never forgive me. I'm mashing together linseed oil and colour to make my first batch of oil pastels.

Sometimes, if you wish hard enough dreams can come true.

I always thought tears of joy were a fantasy. Maybe it's because nobody around me was happy enough to trip the waterworks, and most of the time when I saw tears, they were born from tragedy.

DREAMING IN COLOUR.

Until one incredible day. I came home from school to find a box of watercolours on my bed, proper grown-up in-tube colours. Now, I'd been quietly coveting them for weeks, which felt like months. Pressing my nose against the window of the art shop on the way to school. Asking Mum for them was the equivalent of asking for a ticket to the moon on a spaceship, so I kept quiet. I had no idea, but my mum was keeping quiet, too, as she was slowly somehow saving up for them. Sometimes, if you wish hard enough dreams can come true.

Then, in 2016, she delivered something else. Something that would change my life like nothing else. She called me, having read an article about a new super-black material. This stuff absorbed 99 percent of visible light. If you were rich enough to coat something in it, you could make 3D things look like black holes. My mind raced to all the possibilities until she gave me the punchline: only one artist was allowed to use it, and that artist was the billionaire Sir Anish Kapoor. There it was again, that elitism thing. My heart sank. I could only imagine all the artworks that would never get made, not just mine, but in general. I looked into it and it got worse: Fashion designers, jewellers, car companies, and architects could all ring up the creators of the material and pay them to coat things with it, but if you were an artist, you were told to sling your hook. Kapoor had the monopoly.

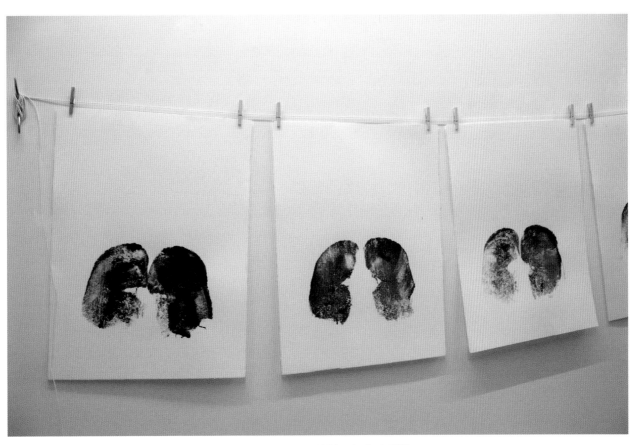

Stuart Semple, *MY AR*E (on the line)*, 2021

COOKING UP COLOUR

Of course, I'd been making paint forever, and during my late teens I started making acrylics. Each time I did a painting show, I'd concoct a new colour, partly because all the art shop paints weren't vibrant enough and I was looking for that Van Gogh level of impact from my palette. Anyway, I'd made the Pinkest Pink and decided I'd put it on a website as a piece of performance art, and make it so anyone in the world could have it, like a mail-order artwork. The only condition would be the buyer would have to confirm they weren't Anish Kapoor, weren't associated with him, and to the best of their knowledge, information, and belief, the Pinkest Pink wouldn't make its way into his hands. Anyway, after that, all hell broke loose. It went so viral that artists all over the world were ordering it. I was totally unprepared, I didn't think anyone would actually buy any. Before I knew it, Kapoor himself had got his hands on some and posted a picture on his Instagram that upset everyone even more.

Liked by **elinorsahm** and **5,361 others**
dirty_corner Up yours #pink
View All 1,285 Comments
foxx.one There's a ethos humanity should normally follow...For the many & not for the few. It's pretty a pretty stinky situation & I do hope you will #sharetheblack Mr K
23 December 2016

Stuart made a painting in oils of Kapoor's Instagram post.

MADE THE PINKEST PINK AND DECIDED I'D PUT IT ON A
?SITE AS A PIECE OF PERFORMANCE ART, AND MAKE IT SO ANY
IN THE WORLD COULD HAVE IT, LIKE A MAIL-ORDER ARTWORK

(Opposite) Objects painted in Black 3.0 absorb so much light that they look flat.

MAKING COLOURS FOR EVERYONE.

Before long, the art community was asking me to make a super black to rival Kapoor's. So, I set about working with some scientists; we knew we could do it, but there was no way to afford it. A crowdfunding campaign later and Black 3.0 was born. The blackest paint you can get, an acrylic that anyone—apart from Kapoor—can use affordably. Funded by the community and tested and tweaked by thousands of artists.

Of course, it's not just Kapoor who has tied up colours in legal controls. So many brands now stake claim to the hues that nature has been producing since day dot. Tiffany owns the rights to a certain blue. Pantone has a whole colour book you need to pay to access, and Mattel owns the particular "Barbie pink." Let's not forget the Yves Klein blue, too. I've been gradually working through all of these colours and slowly making them available to artists because I really want them to be able to use them.

It's not weird for my studio to make paint, up until the Victorian times all artists made their own. The difference is, I don't keep the paint we make for my work only. I like to share it with everyone.

So many brands now take claim to hues that nature has been producing since day dot.

Tiff blue is a paint made in response to Tiffany & Co.'s exclusive rights to the colour.

FEEL THE RAINBOW

I can't write a book for you and not try to impart, at least, some of my love and passion for colour, which means you have to get your hands dirty. I'm not going to teach you anything about warm and cool colours, contrasting colours, or colour wheels. You can find that somewhere else.

I want to show you how colour can stimulate your visual senses, to get a grip on the way this direct experience can transport you emotionally. If you can harness this idea, you will have one of the most powerful tools at your disposal. You can incorporate colour into just about any artform, and you can use it to your advantage as a way to completely change the emotional tone of what you create and share.

Each pair of dots is the same colour, but they look different because the colour around each dot changes how you see it. Experiment by making your own colour relationships.

The first thing to know is that there's no such thing as an absolute when it comes to how we all perceive colour. I keep banging on about how you and I have a different idea of the colour red. If I ask you to picture a red apple right now, I can guarantee that you and I have something totally different going on in our little grey cells. There's no right, there's no wrong. The whole thing is relative.

The way we see colour is influenced by what we see before and after it. Have you ever gone into a perfume shop, a posh one where they spray the scents on little strips of paper? Between each smell, they ask you to smell coffee beans. They do that because the last smell will influence the next.

Josef Albers (one of the Bauhaus lot) did a lot of work on this and I think he described it best, saying it was a bit like putting your hand in buckets of warm, lukewarm, and cold water. If you start with warm water, and then lukewarm, the lukewarm water will feel cold. But if you start with cold water and then put your hand in the lukewarm bucket, it will feel warm. Colours work in the same way.

EVERYTHING IS RELATIVE.

You'll need some paint and coloured paper or a drawing tablet, if you have one.

I want you to explore the way colours react with each other. Their context is everything.

Using four colours, make a series of concentric circles with them. Changing how big each circle is and how much of a part each colour plays can totally transform how they look.

Select a colour and paint it on your paper, then paint a different colour around it. Now, right next to it, use the same colour you first used, but, this time, paint a different colour around it.

Be experimental. Be like a scientist trying to work out the effect each combination can give you.

Although the colours in the middle are the same, isn't it wild how the context transforms them into something else?

COLOURS ARE ACTORS.

When you look at anything printed, even this book, the images are made up of tiny little dots that are close enough together that, when you get a bit of distance from them, they give the illusion of various colours, though they're not really there. They're in your head. I promise you, this book is made up only of cyan, magenta, yellow, and black dots in different proportions.

Albers spoke of colours as if they were actors; he said that a play would be very different if an actor were playing a lead or a supporting role.

I'd love you to pick just four colours and make a series of concentric circles with them.

Do this a few times, sometimes with bigger or smaller circles of each colour. See how different the feeling is in each set of circles, even though they are made up of the same ingredients?

Can you write an emotion under each set of circles?

Can you start to see how you can combine colours to suggest feelings?

FEEL THE RAINBOW

COLOURS HAVE MEANINGS.

Depending on where you grew up, how old you are, and what you've lived through, colours will have different meanings for you. I grew up in the '90s in the United Kingdom so bright neon colours, and some pastels, feel sort of nostalgic to me. They remind me of TV shows I saw as a kid, clothes, and even the kids' lunchboxes from school. Different places and different cultures see colours in totally different ways. There really is a sociological as well as psychological edge to what colours mean.

Saying that, some colours are almost universal. If you put yellow and red together as stripes, it creates a feeling a lot like danger and will get attention. You won't be able to avoid looking at it. Obviously, that comes from nature and things that might have stung our ancestors, so those experiences need to jump to the front of our minds to keep us safe. We are hardwired to scan our world for danger rather than safety. You can use this idea to make work that cuts through the noise.

As I said, every time I had an art show, I'd create a new colour, and I'd give the colours names like Ray Gun or Orange Aid. I think it would be interesting for you to develop your own personal colour vocabulary, too. So like words, you can pull the colours out and use them when you need them. This is a subtle and individual thing, so don't rush it.

Whatever you chose as your capture device—a notebook, your phone, or emailing yourself—write a list of ten emotions or feelings on it.

Think about what emotions your circles convey.

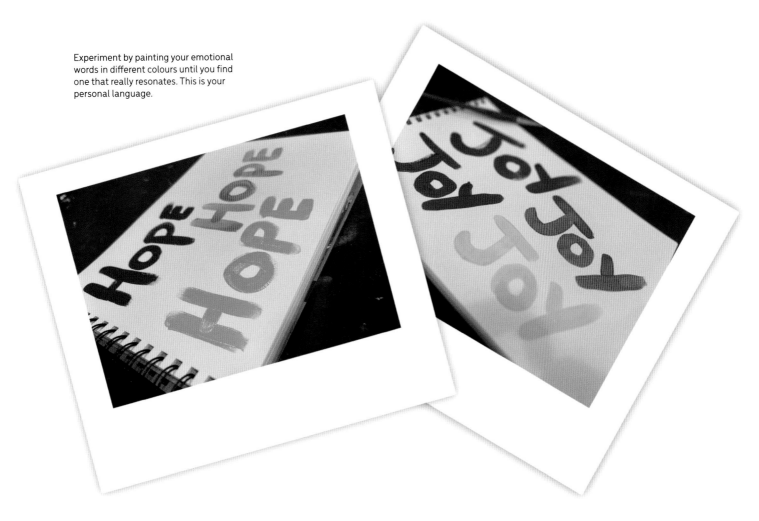

Experiment by painting your emotional words in different colours until you find one that really resonates. This is your personal language.

YOUR TRUE COLOURS.

Now, take those words you just wrote and paint them in different colours. At some point, you'll hit a colour that really resonates with the word. It will just kind of "click." This is your personal colour for that feeling. Once you have a few colours worked out, you'll have a language you can tap into anytime you want a shortcut to that emotional state.

You might even harness some of what we learned before and find a way to share your colours. Remember that person in your class who wouldn't share their colours? Well, they never had many friends. The rainbow belongs to all of us, so don't hoard it. Your true colours are beautiful and they need to be unleashed.

SCAN TO VIEW AN EXCLUSIVE VIDEO FROM STUART!

The key idea wi
art is one of ran
some kind of sy
us interact with

ness and
that lets
machine.

GENERATE IT

t's see how taking some
ks might help you make your
t even more interesting.

GEN ERATE IT

GENERATE IT

LET THE SYSTEM SURPRISE YOU.

Don't be freaked out by technology. Honestly, it's just
a tool you can use to expand your ideas and take your
work into new territory. We really need artists like you to
harness it because, in your hands, it can make beautiful
things. Technology doesn't have to mean computers; we
can create our own systems to help us give up some control
and embrace randomness. Let's see how taking some risks
might help you make your art even more interesting.

GENERATE IT

When I was eight, Mum had a bright idea and sent me off to learn how to program computers. With a few simple lines of code, colours, shapes, and patterns would appear on the screen. Roll the clock forward more than three decades and systems are still a huge part of my process.

Let's explore generative art for a moment. I know, I know, it might sound a bit scary or weird, but don't worry, I don't expect you to be able to write code to understand how systems can help us make work we've never even imagined. Those systems could be as simple as the roll of a die or a series of random things that collide. You'll see—it's easy!

For a long time, many artists have wanted to get out of the way of their work, to take their ego out of the process. Famously, Warhol said he wished he was a machine. In a quest for new breakthroughs, artists always look for ways to generate new paths in their work. This could be no truer than in generative art.

The key idea with generative art is one of randomness and some kind of system that lets us interact with a machine. The point of this randomness is to give us an array of possibilities to choose from.

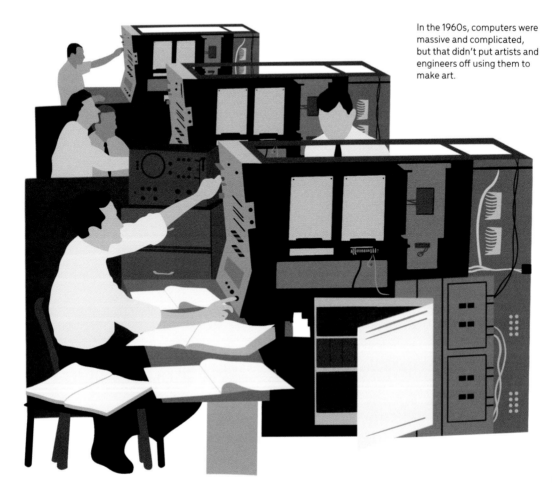

In the 1960s, computers were massive and complicated, but that didn't put artists and engineers off using them to make art.

The poin
give us

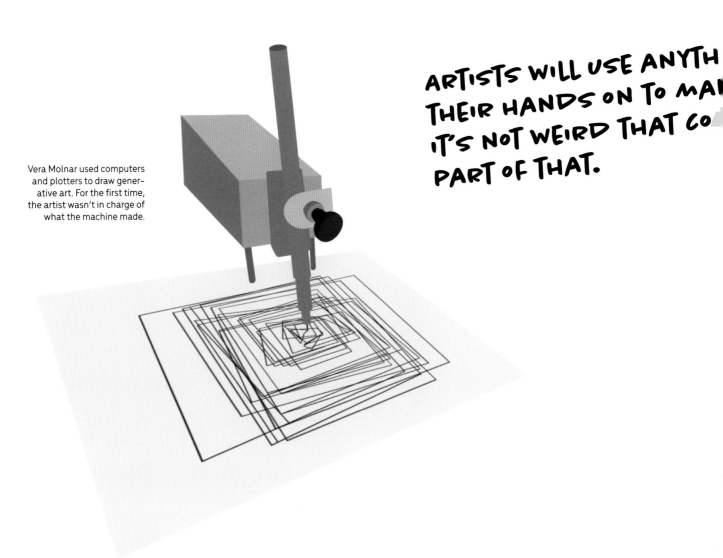

Vera Molnar used computers and plotters to draw generative art. For the first time, the artist wasn't in charge of what the machine made.

ARTISTS WILL USE ANYTH
THEIR HANDS ON TO MA
IT'S NOT WEIRD THAT CO
PART OF THAT.

Although technology has been used by artists since the 1950s, there was randomised art made way before that. Remember Duchamp's urinal? Well, I reckon that a series of quite random events occurred to make that work exist.

If we look at the history of generative art, there's no doubt it goes hand in hand with the growth of technology. Artists will use anything they can get their hands on to make their work, so it's not weird that computers would be part of that.

BIG CLEVER MACHINES.

In the 1960s, computers were really complicated and needed massive rooms to house them. Then, artists like Vera Molnar (Hungarian, 1924–2023) made their way into the tech labs (in her case, in Paris) and embraced them. She used the computer to take the systems she was already playing with into the digital age. Her first generative works were drawn by a plotter. These computer drawings are built upon each other, with her adjusting the algorithm each time to build upon the last drawing. The series entitled *Interruptions* is a really important moment because the artist's hand disappears and the computer itself makes the work.

his randomness is to
ray of possibilities

Since computers became more available in the 1980s, artists have used them to generate art in their studios.

At the time, it was so geeky and hard to do that the majority of art generated by machines wasn't really made by artists—the really early stuff was done by engineers and mathematicians.

The big shift came in the 1980s when computers became much smaller and more affordable and then started to make their way into artists' studios. There was an explosion in the work created at that time, and then again when the internet opened up. Then, again, with smartphones and the advent of AI. It seems that whenever there's a technological leap, generative art takes a leap, too, and so do artists.

I don't want to get stuck on the nerdy side of it, though. It's easy to fall into the realm of computer science and forget the point. I want to stay with the idea that if you give up some of the control and let some kind of system suggest what might get made, you will, potentially, uncover artworks you may never have imagined.

A SLAVE TO THE TECH.

The best example of this I can think of is Keith Tyson's (English, born 1969) random Artmachine. Tyson is a big gambler and absolutely obsessed with chance and risk. He's always been into computers, even taking apart a broken ZX Spectrum as a child to see how it worked. The experience left him clueless. He's interesting, though, because he doesn't believe he has much free will at all; he feels as though there's a program running in the background of everything he makes or does, his own conditioning. That programming comes from what he's seen, how his parents raised him, and his sense of what's right or wrong. He sees the things he does as a kind of software, and the secret hidden code in his subconscious mind is kind of like the hardware.

In the 1990s, he built the Artmachine, a computer that connected to the internet and randomly dictated artworks for Tyson to make. It could point him to books and flow diagrams, too. He would dutifully create what he was told. There are still more than twelve thousand works it suggested that never got made. However, Artmachine had him produce objects, paintings, drawings, photos, and installations. Some of the best were a 7-metre (7.6-yard) painting made out of bathroom sealant, and a painting comprising music CDs and toothpaste. Or even casting all the items on the KFC menu out of lead.

Then there's Dmitri Cherniak (Canadian, born 1988) who has been making generative art since 2014. He loves the idea of using the tools that giant tech companies use to generate visual art. He's trying to determine whether a machine can create work in a fraction of a second that can move us emotionally in the same way a painting might. He can see that the creativity he needs to make his algorithms create work is the same creativity that more traditional artists might bring to the table.

The thing is, to open ourselves up to what is possible, we need to drop the assumption that we know what we are doing. There's a humbleness in just letting things be and in being brave enough to use tools that aren't necessarily associated with art. Maybe nowadays we take for granted the fact that we all have a computer in our pocket or an internet connection in our house, but we mustn't overlook the fact that, as artists, we can use that to inspire creativity.

THERE'S A HUMBLENESS IN JUST LETTING THINGS BE AND IN BEING BRAVE ENOUGH TO USE TOOLS THAT AREN'T NECESSARILY ASSOCIATED WITH ART.

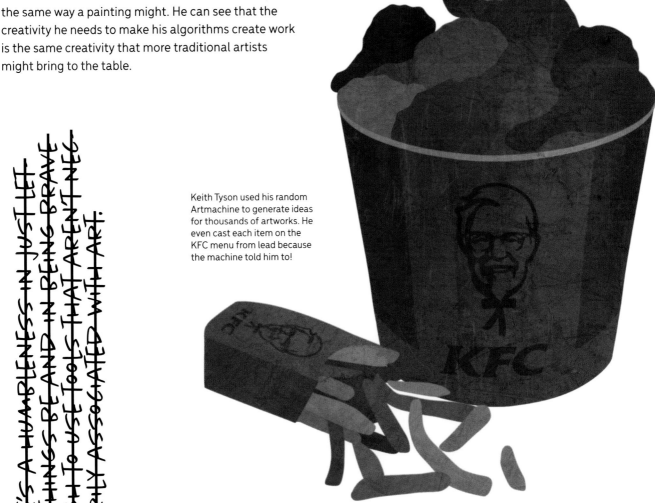

Keith Tyson used his random Artmachine to generate ideas for thousands of artworks. He even cast each item on the KFC menu from lead because the machine told him to!

MY GENERATION

some kind of magic.
...nt on this stuff with
...d then it would look like
...until it dried out and
...white paper again.

One morning I woke up, bolt upright, sweating. I'd seen something in my dream. It's happened once or twice before, but this time was a bit different. I saw a painting that painted itself; a painting that didn't need an artist. Something there was no way to control. The big thing was that it looked emotional, like it was crying.

I desperately wanted to make that dream real. I'd been experimenting a lot with a special paper from China that was used traditionally to practice calligraphy. It was some kind of magic. You'd paint on this stuff with water and then it would look like black ink until it dried out and became white paper again. I figured out how it worked: It was just a bit of fabric that became transparent when wet with another piece of fabric, which was black, behind it that showed through.

Stuart Semple, *Black Rain*, 2019

A PAINTING MACHINE.

I took the paper and stretched it over a frame and started experimenting with ways to drip water on it. In the end, I got my hands on a watering system for tomatoes that would build up water and then randomly drip just like rain. Then, my first black rain painting was born—a work that would paint itself, constantly morphing. The painting cried black tears that flowed over its pristine surface, its scars slowly evaporating before flowing again. It wasn't me being clever, in fact, I didn't do anything really. The machine itself was capable of a sort of mesmerising beauty that, quite honestly, freaked me out. Since then, I've been dreaming of making a whole room cry.

DIGITAL LOVE.

As I told you, I fell in love with code as a child. In 1988, computers were, literally, basic when my mum sent me off to learn how to program them. I'd make little arrows move forward, turn right, and draw a square, then blink before making a bleeping sound. It wasn't long before I was obsessed with it as a kind of creative outlet. I've never stopped using it and the machine is a staple in my studio.

MY GENERATION

Stuart Semple, *Lovetone*, 2021
From a distance, *Lovetone* looks like a grey square, but close up, you can see it's made up
of more than sixteen million uniquely generated random colours.

Randomness is something I adore, too, as well as the ability that machines have to carry out actions non-emotionally. I know that on a computer screen, there are sixteen million-plus colours. I know that the pixels on the screen are either red, green, or blue. I was so desperate to see every possible combination of red, green, and blue—all sixteen million possibilities—that I wrote a bit of code and I asked the computer to randomly generate a colour until it had done all sixteen million unique versions. Then, I asked it to plot them on a grid. It made sixteen million unique dots. Up close it was a universe of colour, but from a distance, it read like a very dull mid-grey square. Sadly, all the colours together made grey. I worked out how to print them large, and made a series of *Lovetone* prints that were entirely generated by the computer.

Sometimes, I feed images and song lyrics into databases and let the machine tell me what to make. It's no different than Keith Tyson, with his random Artmachine, except this is all about making paintings that might surprise me. Every now and then, the computer comes up with a combination that feels, in some way, profound, or at least profound enough to take the time to paint. These generated works feel so different from the work I decide to make; putting my emotions and history to one side is often brilliant.

CUT UP AND KEEP.

Did you know that David Bowie (English, 1947–2016) did it, too? He'd grab the newspaper and cut out phrases, then piece them together to make poems that became songs. He stole the idea from Allen Ginsberg (American, 1926–1997), the beat poet. I've always been into that, the flow of words that conjure pictures when we stop controlling them and just let them dance together. In one work, *Like Tweet Share Repeat*, I made a website that would pull random images and text from social media sites and serve them up continuously in random combinations. It was like a technological cut-up. Sometimes, I'd spy on it and find it had done something wonderful; other times it was terrifying, speaking of how hollow and desperate people's lives on social media really were.

You shouldn't be scared of technology, and you mustn't be worried about people criticising your use of it. At its best, it's a tool to help you get out of your own way—if you're brave enough to let it surprise you. There honestly is poetry in systems, a kind of rhythm that has a beauty. If you let that surprise you, you will end up someplace entirely new.

At its best, it's a you get out of you you're brave enou surprise you.

Stills from liketweetsharerepeat.co.uk, a website that randomly trawled social media for images and text to create unique artwork in real time.

SET THE CONTROLS FOR THE UNKNOWN

Are you ready to hand over the controls of your work to something else? To have your work generated by chance? If so, let's explore how to introduce spontaneity into your ideas. Although we won't delve into computer-generated work right now, I'll point you to some cool information for that in the Resources section. Be sure to check it out if you're interested in incorporating tech into your creative process.

LET'S GET PHYSICAL.

To start, you'll need a die, but don't stress if you don't have any; you can visit random.org instead, a brilliant website for generating randomness. It offers various tools, including virtual dice, which you can use for these exercises.

Boxing Lines. Grab your die, a sheet of paper, something to draw with, and a straight edge (like a ruler or a book).

For this one, you'll need a die, which will become your random art generator.

1. Divide your paper into six sections and write a number (one through six) in each corner.
2. Roll one die and draw a straight line in the section corresponding to the number rolled. For example, if you roll a four, draw a straight line in section four in any direction you prefer.
3. Continue until you've drawn a line in each box (you'll likely have multiple lines in each box).

Simple! But what an amazing way to generate a gorgeous piece of work.

Divide your paper into six sections. Roll your die and draw a straight line in each section. Keep rolling until each section has a line in it.

NUMBER	ARTFORM	MATERIAL	PROMPT
1	Painting	Earth	The thing you should say
2	Idea	Metal	I am
3	Performance	Paint	Show me something I don't know
4	Sculpture	Fabric	Silence
5		Other	Mirror
6		Wood	Poetic Justice
1		Pen	Denial
2		Food	Peace dog

Create your table of variables.

FORTUNE-TELLER.

Remember those paper fortune-tellers from your school days? Well, I've come up with a cunning way to use one to generate random ideas for your work.

This is a bit like Keith Tyson's random Artmachine in that we are going to surrender to the machine and make what it tells us to. But, before we create the machine itself, we need to generate some variables first.

Varieties of Variables. Take a sheet of paper and divide it into four columns.

1. Label each column with the following headings: Number, Artform, Material, Prompt.

2. Under the Number column, list numbers from one to six and add an extra one and two at the end (check out the photo to see what I mean).
3. Underneath each column, brainstorm words or phrases that inspire your work. Feel free to use my examples as a guide, but make this your own.

Remember in the first section of the book when we worked together on making purely conceptual ideas, things you never thought you'd make? Perhaps dig out your capture device of choice and look back over that exercise to bring some of those thoughts back now. If not, don't worry, just use my suggestions or invent something entirely new.

SET THE CONTROLS FOR THE UNKNOWN

Making the Machine. You need a pen and a perfectly square piece of paper to do this. Be sure to look at the illustration to understand what I'm talking about here.

1. Fold the paper diagonally, then unfold it.
2. Fold the top-left corner over to the bottom-right corner. Unfold it again.
3. Rotate the paper 90 degrees and fold the new top edge to the bottom, crease it, and flatten it out. Your paper should now have four lines crossing over the middle.
4. Bring all four corners to the middle of the paper, creating a smaller square with four triangles. Flip the paper over and fold each corner to the centre again.

5. Label your art machine. On each of the eight inner triangles, write a word from your Material column along with its corresponding number, for example, "Wood, 6."
6. Then, turn the "machine" over and, on the front, write your four artforms with their corresponding numbers, for example, "Painting, 1."
7. Finally, underneath each flap, write one of your Prompts, for example, "Poetic Justice."

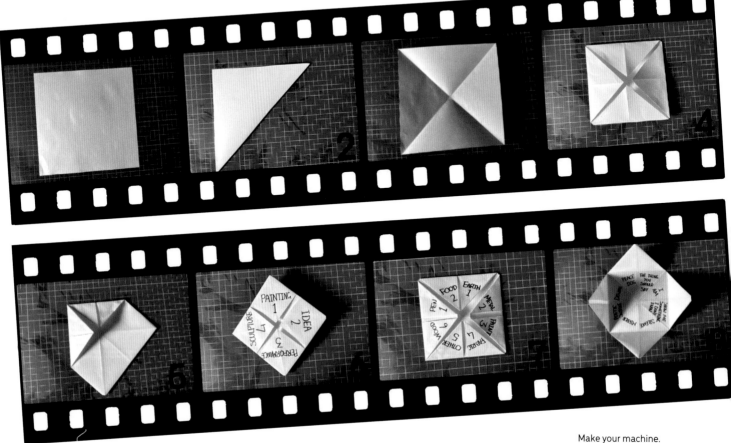

Make your machine.

Let's Generate It. Now's the time to bring the machine to life!

1. Pop your thumbs and index fingers inside the fortune-teller, under the four outer flaps, roll your die, and determine the chosen artform. You may need to keep rolling until you get a number between one and four.
2. Write down the word "painting" in your notebook or capture device.
3. Continue to operate your machine by moving your fingers whilst spelling out the selected word, for example, "p-a-i-n-t-i-n-g." Stop at the last letter and look inside to find four possible materials.
4. Roll the die again until one of the numbers comes up. For example, rolling a six might mean a pen. Write down the word "pen" in your notebook or capture device.
5. Next, spell out your word whilst moving your fingers. In this example, "p-e-n." Stop on the last letter and roll the die again. Let's say you roll a two. Lift up flap number two to reveal the prompt. When I did it, I found "The Thing You Should Say." The machine has now generated the idea for an artwork: Create a painting using a pen about "The Thing You Should Say."

Capture these ideas and consider bringing them to life.

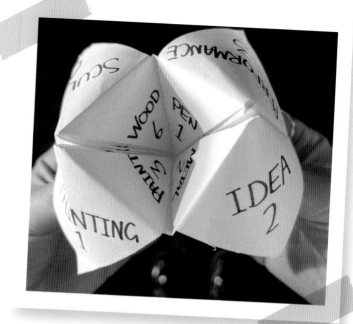

Generate it: Put your thumbs and index fingers inside the machine. Roll your die and start generating ideas for artworks.

SCAN TO VIEW AN EXCLUSIVE VIDEO FROM STUART!

Take Stock.

Before we move on, I want to reconnect and take a moment to reflect on how far you've come in this journey.

Please take out your notebook, journal, phone, or whatever you are using to document your progress, and ask yourself:

- What ideas about making work have I dropped?

- If I could make anything in the world, what would it be?

- What have I learned about myself so far?

- How have I been holding back my ideas?

- Which art movements, ideas, or exercises have resonated the most?

Don't forget, you can share your work on your social media account with #makeartordietrying so we all get to see it. It's so much more fun to know there's a community doing this together.

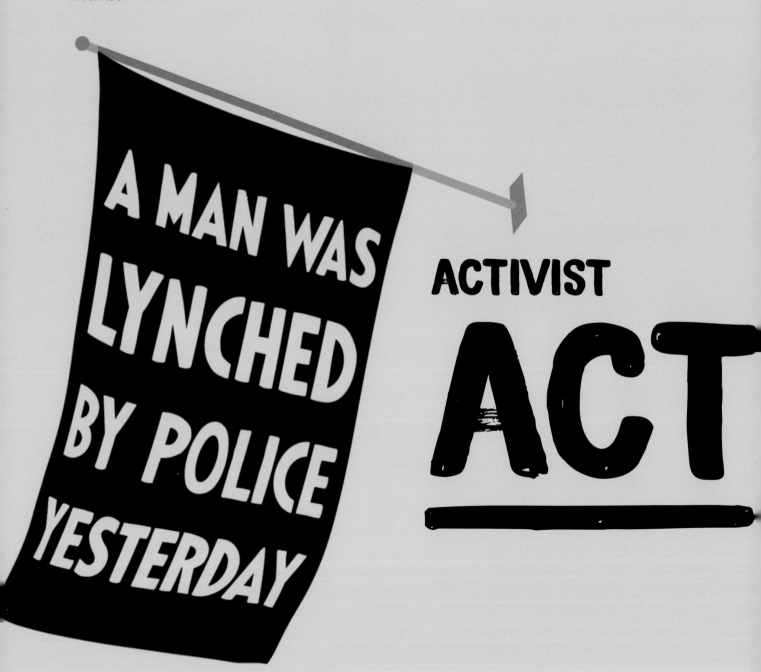

**Chapter Eleven
Activist**

ACTIVIST

ACT

A MAN WAS LYNCHED BY POLICE YESTERDAY

a total myth that artists change things, in fact, the artistic license you were born is the most powerful gift we been given.

ACT
———
IVIST

ACTIVIST

CHANGE HAPPENS WHEN ART MEETS THE WORLD.

Finally, we come to a point together where everything we've stacked in our toolbelts comes into its own. This is the bit where we start to apply it all to the world around us, to take action and make things better.

It's a total myth that artists can't change things, in fact, the artistic license you were born with is the most powerful gift you've been given. It's your way to go where other people can't and I implore you to use it—loudly, daily, and well.

ACTIVISM

Right now so many artists are taking action with their work, and the past is full of examples of those who were brave enough to wield their talents to change things for all of us.

Making art about things that matter is a way to take direct action towards a social or political goal. At their best, great artists help us think critically about the society we live in. That in itself can cause huge shifts. Artists can hold a mirror up to situations that might otherwise be overlooked; they can even make governments accountable. We can use our art to give voice to the voiceless, amplify ideas, and distribute them widely.

Let's fly over to the United Nations headquarters in downtown Manhattan. Outside the chambers of the Security Council hangs a tapestry, a reproduction of one of the most famous and poignant artworks of all time, Picasso's *Guernica*. It acts as a persistent reminder of the horrors of war to the fifteen-strong body of people who meet there to discuss peace and security.

In Picasso's painting, the tree of Guernica takes a leading role, not only as the symbol of Basque nationality but also the place since ancient times where meetings were held to discuss democracy. Back in 1937, the Basque people in Spain were fighting Hitler and the Nazis long before anyone else. They built traditional barricades and armed themselves, but the Fascists bombed them from the air. The loss of life was horrendous. Tyranny won because people with guns were no match for technically advanced violence. The painting captures the horror and the pain, not just in humans but also the livestock. The sword of liberty is shattered to pieces. Rays of hope are overshadowed by bombs, and we are forced to face war in its true colours.

Pablo Picasso's *Guernica*, 1937, is regarded by critics as one of the most moving and powerful antiwar paintings in history.

MAKING ART AB
THAT MATTER
TAKE DIRECT ACTIO
A SOCIAL OR POL
AT THEIR BEST, GR
HELP US THIN
ABOUT THE SOCIET

In 2020, following the death of George Floyd, artists painted on boarded-up shopfronts around the world.

IMAGES HAVE POWER.

Guernica shows the power one image can have to show humanity the horrors of itself. I hope that those who walk past it at the United Nations every day are reminded of the power they have and the importance of their choices. It's had such an impact on so many people's psyche that it's taken on colour, meaning their recollections of the painting are actually in colour; the original is, in fact, black and white, more like a newspaper.

On 25 May 2020, George Floyd, an African American man, was killed in Minnesota, United States. A police officer kept his knee on the side of Floyd's neck for almost nine minutes whilst three other police officers restrained Floyd, who had been accused of using counterfeit money at a nearby market.

What happened next was a global movement around "Black Lives Matter," which was founded in 2013 following the acquittal of George Zimmerman, the man who shot seventeen-year-old student Trayvon Martin. Protests erupted globally and artists, designers, and performers used their voices and platforms to take a stand. Stores boarded up their windows to stop looting and painters quickly used them to create powerful impromptu murals. Meanwhile, in Chicago, "Boards of Change" turned those plywood barricades into voting booths. They inspired residents from dozens of low-turnout communities to register to vote for systemic change.

In Chicago, the "Boards of Change" project saw the painted boards from shopfronts transformed into voting booths, which encouraged the community to turn out and vote for change.

DESIRE FOR CHANGE.

Then, in London, graphic designer Greg Bunbury (British, born 1976) produced graphics in honour of the movement. His most powerful work was a simple poster with the phrase "I can't breathe," a phrase that would go on to be a slogan for the BLM movement. This piece, in honour of Eric Garner from Staten Island, United States, immortalises his words from a video in which he is seen in a chokehold by a police officer before he loses consciousness. In Bunbury's poster, the words are repeated eleven times before a final incomplete line fades, suggesting the loss of breath.

Banbury himself is very clear that a design or art can't solve structural problems, but they can help create an environment where there is a desire to solve the problem.

Between 1920 and 1938 the NAACP would mark lynchings by flying a black-and-white flag from its headquarters on New York's Fifth Avenue. It read: "a man was lynched yesterday." New York city residents were faced with the regularity of these murders all too often. In 2015, artist Dread Scott (American, born 1965) felt that this flag was, sadly, still as relevant in the present day as it was almost a century earlier. He updated the flag to read "a man was lynched by police yesterday." His flag was exhibited on the façade of the Jack Shainman Gallery during an exhibition called *For Freedoms*.

Dread Scott's *A Man Was Lynched by Police Yesterday*, 2015, installed at the Jack Shainman Gallery on July 8, 2016.

...BUT THEY CAN HELP CREATE AN ENVIRONMENT WHERE THERE IS A DESIRE TO SOLVE THE PROBLEM.

In 2012, members of the Russian feminist group Pussy Riot were imprisoned after a provocative performance in Moscow's Cathedral of Christ the Saviour.

RIP KEITH HARING.

There are very few artists who have made such big and important social issues as accessible as Keith Haring (American, 1958–1990) did. He used a cartoonish, fun, even whimsical style to discuss apartheid, AIDS, environmentalism, and how capitalism increases inequality. It's easy to think of his work as superficial, but it's not. Sometimes, it was overt, like the posters he'd hand out at antinuclear and anti-apartheid rallies, but sometimes, it was much subtler. In his later works, made whilst he knew he was dying from AIDS at the age of just thirty-one, he showed us broken birds, daggers, nails, nooses, and blood. This kind of visual activism gives us an emotional connection to the real lives of other human beings, and in that, it invites us to think about new ways of doing things.

For some, speaking their truth with their work carries a very real risk. That's certainly the case for Pussy Riot (Russian, founded 2011), a feminist Russian performance art group, made up of about eleven women.

They performed raucous punk rock performances, wearing balaclavas, at public events in Moscow, filming the work and posting it on the internet. They would often bravely, and provocatively, speak out about LGBTQ+ rights, Vladimir Putin, and the Orthodox Church. Three of the members were imprisoned following a performance inside Moscow's Cathedral of Christ the Saviour back in 2012. They were charged with "hooliganism motivated by religious hatred." The group were making a point about the Orthodox Church having supported Putin's election campaign.

Perhaps here in the West, one of the things we take most for granted is our freedom of expression. In places such as China and Russia, it's very different. An artist's speaking out literally carries the risk of imprisonment, or even death. Yet the bravery of those artists is a reminder for us all that we have a voice and, as a sign of respect to those who risk everything to use theirs, we must use ours.

I'VE STOOD UP FOR WHAT I BELIEVE

I'VE STOOD UP FOR WHAT I BELIEVE

THEY WERE AS CONFUSED
I WAS BECAUSE ANXIETY
IS EXTREMELY PH

In 2013, various celebrities took to social media to wear the temporary tattoo I designed to help raise awareness for and reduce stigma around talking about mental health.

When I was going through hell, calling up the ambulance every couple of days thinking I was dying, nobody spoke about mental health. Plainly and simply, young men didn't have mental health problems, and if they did, there was so much stigma around that you would never tell anyone anyway.

I became an expert at hiding my anxiety. I was so good at it that nobody would ever have known I was terrified to put anything in my mouth or touch stuff that might have an allergen on it. So much so, that the hospitals always treated me for an allergy—to them I was having difficulty swallowing, my heart rate was all over the place, and I was struggling to breathe. They were as confused as I was because anxiety, at its worst, is extremely physical. This loop carried on for months on end until one night, whilst in a hospital bed, a junior doctor explained they weren't sure I was suffering from an allergic reaction, and they thought my symptoms might be caused by anxiety.

Since then, I've been focused on using my work to help and have built a relationship with Mind, the United Kingdom's largest mental health charity. A lot of the work I did with them was around reducing the stigma of mental health and encouraging people to speak up so they didn't have to struggle alone. Here in the United Kingdom, every year, there's something called Time to Talk Day, and for the first one, I designed a series of temporary tattoos and sent them to loads of celebrities. They wore them and took to social media as a sign of solidarity. Then, I made a series of posters that read: "It's totally OK to ask me if I'm not OK," and I distributed them at art fairs. I also made a piece of video work in which a white elephant tries to navigate everyday life and fails. Those works, ultimately, led to the establishment of a creative therapies fund at Mind, which got its cash from an art show I curated. The fund enables people who are struggling to access creative therapies in their community because I know how powerful art can be. Once people open that creative door, that outlet can really help heal. I think, ultimately,

I'VE STOOD UP FOR WHAT I BELIEVE

I took a photo of a bench in my hometown. The bar was designed to prevent people experiencing homelessness from sleeping on the bench.

making art or expressing ourselves is what makes us human, and without it, we can struggle. Sometimes, we can't express how we feel with words—I certainly couldn't, I didn't have any. For me, making my drawings every day was a way to cope and there's nothing that helped me heal more than art. It's fair to say that, without it, I probably wouldn't be here.

One day, I was walking down the street in my hometown, and I noticed metal bars in the middle of all the public benches. After the work I'd done designing a train station and having to deal with all the what-ifs from the local authorities, I understood that the bar was meant to stop people experiencing homelessness from sleeping on those benches. It was so easy to mistake the bar for an armrest, but with the new

perspective I had, I could see it was a cruel and perverse use of design. Remember when I said that bad design can hurt people? Here's an example. Literally, using it to design people out of our public space. So, I put a photo of it on my Facebook, and the next morning, it had gone totally viral with over a million people seeing it. The local council dug in and said they'd never take the bars off. So, I got together with the unhoused community and, together, we decorated all the benches, turning them into "Love Benches," which made the global news and embarrassed the council into taking off the bars—that night, under the cover of darkness. Since then, I made a way for communities all over the world to tag what I call "hostile design" in their neighbourhoods, by sending them removable stickers they can use.

"Love Bench"—I got together with the unhoused community to decorate benches;
the action got a lot of attention and forced the council to take the bars off the benches forever.

GAY BLOOD

ACRYLIC PAINT

A TOOL FOR
BLOODY CHANGE

DISCLAIMER:
This paint is made with the blood of gay
men. Blood that is perfectly safe to use, but
that the FDA has banned from donation
due to homophobic policies. Join us in
fighting back.

BY MOTHER
IN COLLAB
W/ Start Simple

150ML

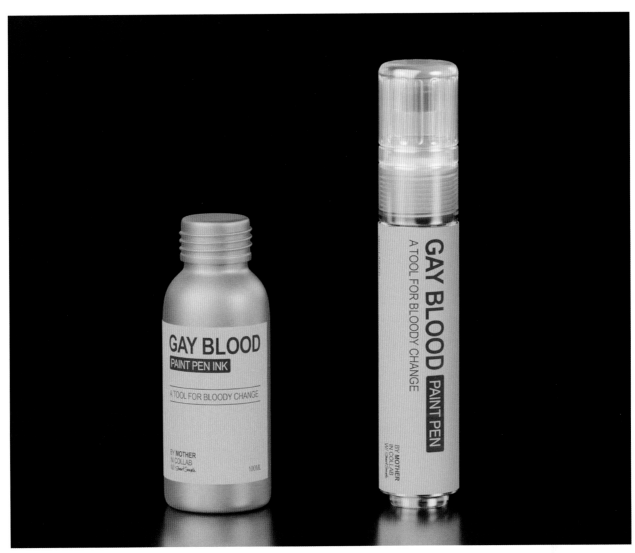

"Gay Blood" acrylic paint, paint pen, and ink enabled other artists to make a noise about the US FDA's discrimination regarding blood donation. Image courtesy Mother, NYC

Earlier in this book, I spoke about "Gay Blood" and the ink I made in the context of conceptual art. I took the project a stage further and worked, again, with Mother in New York. This time we upped the ante and created a whole series of tools for other artists to use to express themselves. We made screenprint inks, fountain pens, acrylic paints, and even graffiti pens and called them "A Tool For Bloody Change." Each art material contained the real blood of real gay men. The idea was to empower artists all over the world to make a statement with these materials and to take a stand against the FDA's refusal to accept blood donated by gay men. To, literally, write their slogans in blood. I don't know how much the action helped, but the US Food and Drug Administration has since changed their rules, and men, regardless of sexual orientation, in the United States, can now donate blood.

(Opposite) Image courtesy Mother, NYC

STAND AND DELIVER— USE YOUR VOICE FOR CHANGE

It's time to turn your work and ideas into powerful forces for social change. The backbone of my work is a quite radical idea: that artists and our work are useful, and actually provide a function to society. So many people feel as if what we do is frivolous, decoration, or a luxury, and in one way, perhaps it is. However, in another, it can be a vital voice of our conscience that can help our moral compass stay fixed to true north when the world gets weird.

YOUR TURN TO HOLD UP A MIRROR.

We are going to make a project about something you care deeply about. Now, sadly, I don't know you, and I don't know what your passions are. For some of you, they will be environmental; for others, it may be your community. You might be moved by racial or sexual inequality, the mistreatment of animals, or corporate greed. You may well be moved by several things at once, but for this exercise, pick the thing that moves you more than anything else.

THE ONE THING.

Zone in on one thing you feel you could really get behind—something you want to draw attention to; something that, if you could raise even a little awareness for, would feel like a positive contribution.

The first thing we are going to do is to name the project. So, spend a little time thinking of words or phrases that you could use to title the work. Pick something memorable, sticky, and simple that really gets to the heart of the issue.

Perhaps, imagine if you were a group, what would you be called?

You can write down all your ideas and, perhaps, even discuss them a bit with friends or family. When you've settled on a name, stick to it.

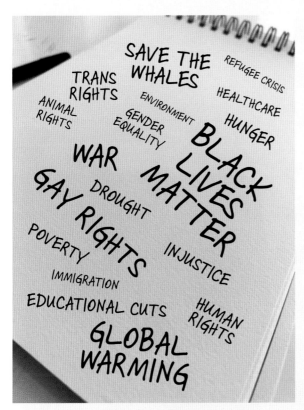

Think about issues that mean a lot to you, things you really care about, and want to use your artistic voice to change.

Make your own protest placard and paint your slogan on it. Take a photo of it and post it to social media using your hashtag.

SLOGANS WORK.

Now, I want to add an element of text art to this art, and use the language of placards. Protest placards are always inspiring and direct. These pieces of text art can often be reproduced on murals, posters, or handouts. They are a great place to start.

To do this, you'll need some cardboard, some paint or markers, and some kind of wooden pole or stick.

1. Think about a phrase that you'd like to paint on your placard. How can you convey your thoughts and passion in just a few simple words?
2. On the piece of cardboard, create your slogan artwork. You can do this in any way that you feel makes sense.
3. Photograph your placard and share it on your social media so the world can see it. Make sure you use the name of your project as the hashtag.

STAND AND DELIVER—USE YOUR VOICE FOR CHANGE

A DESIGN FOR LIFE.

By now, you've created the name of an activist group focused on making something better. You've also created a very powerful message in the form of a simple slogan placard. That's important because it's helped you focus on the crux of your message. As artists trying to make a difference, it's vital to know what we are trying to say so others understand.

The next thing to do is to imagine an idea for a mural. Make a simple list of . . .

- Colours
- Locations
- Objects
- People
- Textures

. . . that fit the idea of your cause. You can draw inspiration from anything in the previous chapters, so you could start to collage or appropriate images that resonate. You can use the techniques of generative art to randomly create combinations that could become your mural. Or you could draw inspiration from art history and artists who have made a statement before you. Perhaps consider using your slogan on the mural.

Now is the time to create your design for the mural; you can use anything available in any way you can think of. Perhaps you'll make a collage, stick it in your sketchbook, and draw over it. You can share your mural design on your social media as a way to broadcast its meaning to the world. When you post it, in the caption, ask a question. If you do this right, you might find that a dialogue starts to emerge.

The best we can hope for as artists is a discussion, and the right work, at the right time, can certainly do that. Don't be afraid to be provocative, to ruffle feathers, to be punky. Remember the irreverent attitude of the Situationists. Stick two fingers up to the problem and watch the world wake up.

Design your idea for a mural.

SCAN TO VIEW AN EXCLUSIVE VIDEO FROM STUART!

Take it out into the real world and make sure you put it where people will see it. Be inventive. #SavetheWhales

START A CONVERSATION.

I want to end this section by taking your work out into the real world. We've gone full circle since the start of the book where we got out and about and looked at happenings. Now, we can use those techniques to start debate about issues that really matter.

1. Get several pieces of paper. On them, write or paint your slogan.
2. After the slogan, write the word "discuss," and add the project's hashtag.

Next, you need to work out how you will distribute the papers: You could photocopy them and hand them out, or simply leave them in public places so people find them. You could even find a rally or protest that fits your project's cause and distribute them there—you might even take your placard.

Obviously, all this is very simple in one way, and there are so many ways to galvanise discussion around your work to help make change. All I'm hoping for here is that you get started. Start expressing your voice through your work and, hopefully, if you've followed these steps, you will have met some other like-minded people and a community, or at least a discussion, might start to hatch around you and your work.

It's about confidence. Using our artistic voices is scary, at first. It takes practice to wield it, and we aren't quite sure of the power it carries or what it's capable of. As you work with your voice, you'll get to know it better, along with other techniques in this book that can be like gold dust to amplify your message.

For now, my advice is to start small and build trust in yourself and in your ability to do this. I know you can, but you need to know you can, too!

Maybe this humble start will build into a movement. Maybe, just maybe, this little idea can ripple into something that makes the world better for all of us.

COLLABORATE

of making work with
radical in the way it
ly dissolves the idea of
idual artist.

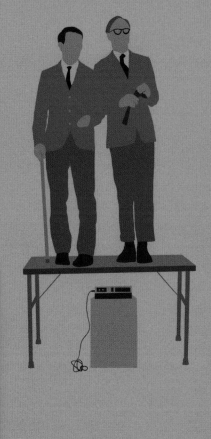

LABO
RATE

In isolation, there's so little we can achieve.

COL LABO- RATE

COLLABORATE

TWO HEADS ARE BETTER THAN ONE.

It's time to step out of your own world and bring all this together by working with others. In isolation, there's so little we can achieve. Let's bin the old idea that we need to be solitary geniuses and embrace the simple fact that, together, in community we are stronger.

This is the bit where everything changes. The idea of making work with others is radical in the way it completely dissolves the idea of the individual artist. No more individual navel gazing—it's time to form a crew.

STOP. COLLABORATE. LISTEN.

General Idea, *One Year of AZT*, 1991
1,825 units of vacuum-formed styrene with vinyl wall-mounted capsules.

So much of art history is filled with the concept that the singular, isolated genius should be celebrated. The art market loves it because it can mythologise these characters and take them all the way to the bank. Collectivist working was a sketchy situation in America in the early days as it felt like it could be a bit Soviet and nobody wanted to risk being labelled "red." Although as you will see, working together really was never about that; it was about exploring and championing ideas that groups and partnerships had in common.

I want to be super clear that I'm not talking about art movements anymore or groups of people that sign up for some kind of manifesto (although some of these relationships had them). I'm talking about groups of people who actually made work together, in a physical sense. Works that don't have a clear singular author.

Shared identity is one of the main things that seems to glue a group together. In the 1960s, we saw that shared identity emerge around groups that were largely ignored by the mainstream art world. We saw AfriCO-BRA (American, founded 1968) come out of Chicago. These African American artists had the goal to develop work for "the whole family of African people, the African family tree." Then, in New York, Chinatown was a hotbed of collaborative excitement, with Asian American artist groups like Basement Workshop (American, 1970–1986) and Epoxy (American, 1982–1992) taking on DIY gallery spaces.

Epoxy made murals, photocopy art, and, in 1987, a large wall piece called *36 Tactics*. It put words from Sun Tzu's (Chinese, 771–256 BCE) book *The Art of War* over images of world leaders. Meanwhile, General Idea (Canadian, 1969–1994), a Toronto- and New York–based collective, began focusing all their attention on the AIDS epidemic at the end of the 1980s. In the early 1990s, they made, perhaps, their most impactful work, which was called *One Year of AZT*. In this piece, they covered all the walls of a gallery with plastic versions of the AZT pills, which one of their member, Felix Partz, was taking at the time for HIV. The 1,825 pills signified the number of pills he would consume in a year.

GILBERT & GEORGE.

My teenage years were influenced by several artists working collaboratively. At that time, a lot of artists met at art school and started doing shows together and, in the end, some also started working together. Gilbert & George (British, born 1943 and 1942, respectively) were like royalty in London at the time. The duo had been doing work together for what seemed like forever and a lot of the new generation looked up to them.

Gilbert & George have been at it now for more than fifty years, having met as students at London's St. Martin's School of Art. They quickly hit it off and became "living sculptures," wearing distinctive suits and performing simple actions like covering their heads and hands in metallic powders whilst singing classic British songs, such as "Underneath the Arches," standing on a table. It wasn't long until they started making large photo-

SO MUCH OF ART HISTORY IS CONCEPT THAT THE SINGULAR SHOULD BE CELEBRATED. THE BECAUSE IT CAN MYTHOLOGISE AND TAKE THEM ALL THE WA

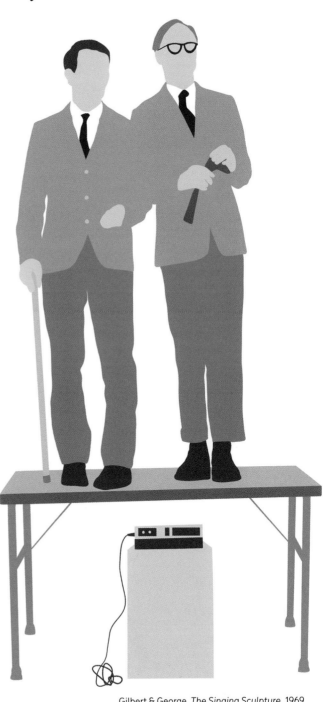

Gilbert & George, *The Singing Sculpture*, 1969

graphic works together, too, that they call "pictures" and see as love letters to the viewer. These pictures are often in a grid formation with bold block colours, dealing with topics such as identity, Britishness, and countercultural movements. The pair are rarely seen apart, and almost never out of their uniform suits. They are a testament to a long, fruitful working relationship that continues to question and challenge audiences.

Tim Noble (British, born 1966) and Sue Webster (British, born 1967), *Miss Understood & Mr. Meanor* 1997
Artists Tim Noble and Sue Webster proved that two heads are often better than one. They started working together in the 1990s. In this series of works, they took personal items and trash, and projectors to make complex shadows.

Then, in the 1990s, a stone's throw away from Gilbert & George's studio, we saw Tracey Emin and Sarah Lucas (English, born 1962) opening The Shop together in the East End, selling trinkets that they made together—things like ashtrays with Damien Hirst's head on them and little pin badges. Their place was the place to hang out.

COLLECTIVE SPIRIT.

At the same time, perhaps my favourite art group of all time, BANK (English, 1991–2003), were putting on group shows all over the place. In fact, they curated more than twenty, and they were hilarious and brilliant. They also made a magazine in a tabloid satirical style, which focused on what was going on in the art world, with headlines like "Galleries 'All Owned By Rich People' Shock." They also had a *Fax-Bak Service* with which they'd take press releases from galleries, destroy the "art speak" by correcting them with a pen, and then fax them back to the source. BANK were brilliant, and I just don't think any of the last twenty or so years of contemporary art would have the same wit and irreverence without them. They took a DIY spirit and showed how it could work. I don't have enough words to share their brilliance, so do yourself a favour and look them up, right now, go down a rabbit hole and come back and thank me later.

No discussion on collaborative groups would be complete without taking a look at Guerrilla Girls (American, founded 1985). They've been making some of the most important and provocative work for about four decades. It all started when the Museum of Modern Art in New York hosted a massive painting and sculpture show in 1984. The problem was, of the 169 artists with work in the show, only 13 were women. So, the group formed and started hiding their faces behind gorilla masks and removing their names by taking on the names of dead female artists such as Ana Mendieta (Cuban American, 1948–1985) and Frida Kahlo (Mexican, 1907–1954). Since then, the Guerrilla Girls have been a voice that constantly challenges the racial and gender imbalances within cultural institutions. As their name suggests, they often incorporate guerrilla activities to challenge the status quo. This kind of "culture jamming" comes out

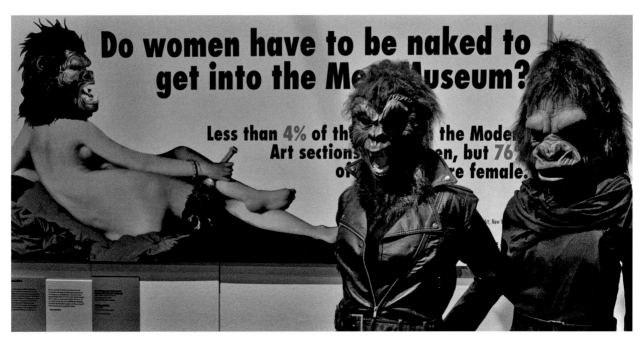

Guerrilla Girls, Victoria and Albert Museum, London.
Photo by Eric Huybrechts, 2014

via billboards, books, posters, lectures, and appearances. Probably their most famous work, and the one that had the biggest impact on me, is a poster that spells out the fact that only 5 percent of work in the Museum of Modern Art is by women, whereas 85 percent of the nudes in the museum are of women.

A couple of collectives after my own heart are Shanzhai Biennial (Chinese, founded 2012) and GCC (Arabian, founded 2013). Both groups use the tools and language of corporate culture to challenge systems of capitalism from the inside. In 2014, at the Frieze Art Fair, Shanzhai Biennial ("shanzhai" is a term for Chinese counterfeit goods) set up a stand selling a £32 million (almost $40 million) property. The GCC, which stands for Gulf Cooperation Council), met in the VIP area of the Dubai Art Fair and, since then, the group of eight artists have made a daytime TV show and even published a book of their WhatsApp chats.

We don't get to hear nearly enough about collectives. Most galleries prefer to represent single artists rather than groups because, often, the work of collectives is complex and challenging, comes out of real social issues, and is actually born from a dialogue. The truth is that stuff is hard to sell.

The Guerrilla Girls ha[ve] voice that constantly c[...] the racial and gender in[...] within cultural institutions[...] name suggests, they ofte[n...]

Every artist needs musicians need engineers to record producers to make work, and the best dance choreographers.

NO PERSON IS AN ISLAND

NO PERSON IS AN ISLAND

There's only so much you can do on your own. Sure, you can lock yourself away with a stick of charcoal and some oil paint, navel gaze a bit, and dream about a future. There's nothing wrong with that, but there comes a time when you need to get other people involved. You need to learn to collaborate.

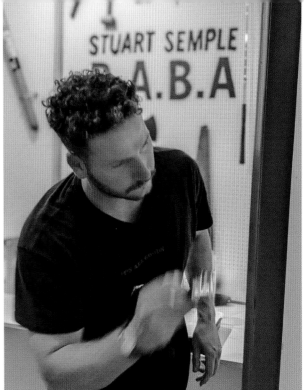

Josh and Jamie (The Syrup Room) have helped me make my work for ages. Here, they are doing what they do best—putting the special finishing touches on the art.

STOP.

Now, I'm going to deal with something right here and now that seriously winds me up. There is a huge misconception that unless an artist does it all with their own hands, they are in some way cheating. That's ridiculous. Every architect needs a builder; musicians need engineers and record producers to make their work, and the best dancers need choreographers. Almost no film in the history of the moving image has been made by a single person.

So, I'm saying now and loudly: Artists can and should be supported by others, and can and should be tapping into networks that have skills they don't. Your job is to distribute your ideas and to give the public the greatest chance of connecting with them. You simply can't do that alone unless you're extremely lucky.

One of the greatest relationships in my life is with Josh and Jamie. I've known them for over a decade, and they can fabricate things. Not only that, but they also understand me, and can help my ideas exist in the world. From building artist job centres to making clouds fly over music festivals or even creating tables out of single pieces of plywood—without them, I couldn't do it. So, it's important to start building relationships with people around you who can help you, too.

LISTEN.

That said, the biggest collaboration you can find, the one that teaches you the most, and the one that will constantly surprise you, is the relationship with your audience. The minute you enter a dialogue with them and you become receptive to them, you will have the best teachers imaginable. That's a controversial thing to say because a lot of artists will say screw the audience, make your stuff no matter what. I'm telling you the opposite and that comes from what I've experienced. The more you care and listen to your audience, the more you serve, and the stronger you get. Of course, be critical—not all feedback and advice is useful—but be humble enough to know there's plenty you simply don't know.

NO PERSON IS AN ISLAND

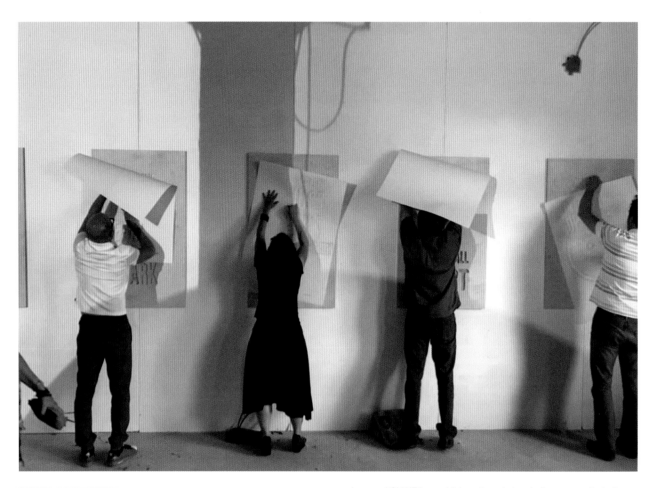

I opened GIANT in an old department store in Bournemouth during the pandemic. Here are some photos from the first show I curated there called *Big Medicine*.

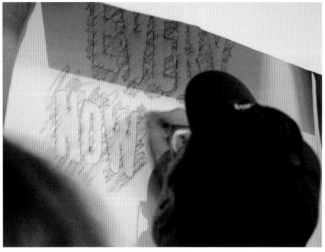

Audience feedback is something I constantly lean in to. Quite often, I make half-finished paintings that take the form of the "World's Largest Colouring Book," in which anyone can sit around a table together and paint the pages. Or paint by numbers–style installations in galleries, where visitors have the freedom to finish the work however they like, and, sometimes, giant wall panels that visitors can make rubbings from using wax crayons. Every day, I see what artists create with the paints I make in my studio, and it feels like the greatest collaboration of all.

GIANT.

Probably the biggest collaborative project I've ever taken on besides my studio is GIANT. At the tail end of the pandemic, I was offered an entire floor of a recently closed department store, and I worked with an amazing group of people to transform it into the United Kingdom's largest artist-run gallery space, where we hold major exhibitions by internationally renowned artists, right here in my little seaside hometown of Bournemouth. We have welcomed hundreds of thousands of visitors who had free access to art that would not have been possible before GIANT.

I want to leave you with something important: Your ideas are not more important than other people's ideas. You may believe in them, fight for them, and single-mindedly push them through. If you've been lucky enough to pluck a big idea out of the ether, it's your duty to carry it. However, that's not the end of the story. Until that idea finds a relationship with other people, it's not truly born. To make ideas fly, they need help, and they need an audience. You can learn more about your work by working for and with others than you ever can on your own. In the friction of compromise and the acceptance of other people's input, you can start to find stuff that's truly great.

The bravery comes now, where you surrender to this new way of looking, and understand that this is a way of life, a way of being. This is the bit where you declare yourself an artist and never ever look back.

With work by Paul Trefry (Australian, born 1967; *left*) and Chad Person (American, born 1978; *right*).

Jake and Dinos Chapman
(British, born 1966 and 1962, respectively)

No gallery is complete without visitors.

At the Happiness HQ in Denver, visitors participated in making their own art.

IT TAKES A VILLAGE

So, here we are. It's been quite a journey. I hope you've done at least some of the exercises I've shared. If not, just reading them and imagining doing them is an education in itself.

If you've gone through the book and actually done the work, well done because you've now built up a series of works and perspectives that will enable you to really make artwork with your unique voice—work that's conceptually strong, connects with audiences, and might even contribute to making things better for the world in some way.

I'm going to end this with the biggest of all ideas: No human is an island, and it takes a village to make ideas take root and spread.

This final instalment is about collaboration. Hopefully, you can see that, throughout this book, you and I have been collaborating. You've been through a process that has only just started, and I want to keep in touch and be part of your next chapter. So, please make sure you reach out and connect with me. Make sure I see what you make and where you go. You can simply search my name on social media and it will be a true joy to hear from you.

Let's end as we mean to go on with one last set of making together.

Maybe you have some kind of community already—is it your family? A group at your school? Who knows, maybe you've managed to meet some like-minded people through the process of working through this book. Now, I want you to try to come together with others and actually make something.

THE DOODLE CLUB.

You're going to start a doodle club because when we get together, and chat and make things together, magic happens. I can't overstate the power community has to contribute to positive mental wellness, or the way it can incubate and encourage huge ideas to hatch.

Your doodle club is a great place to discuss what your collective can do. Look at the conversation prompts and explore where doodling and chatting can take you.

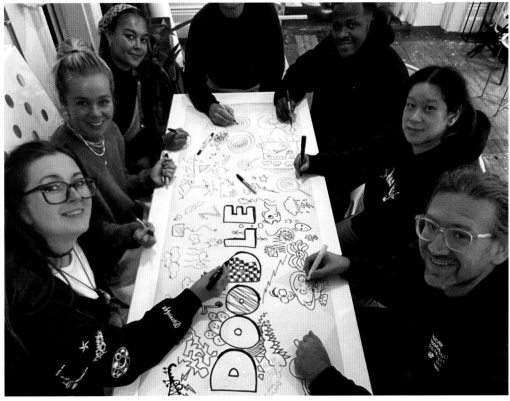

You're going to need:

- A date and time
- A group of a few people
- A table and a big sheet of paper (I've found lining paper from the DIY store to be amazing, it's really inexpensive and a big roll enables a lot of doodling.)

You're simply going to invite your group to your doodle party, let them know that you'd love them to bring some pens or paints, or anything to doodle with. Be really clear that it's just doodling and nobody has to be any good at art. Your mission is simply to sit together and doodle for an hour or so.

THE ART OF CONVERSATION.

Whilst you're at it, here are a few topics of conversation:

- Could we make a happening together?
- Is this a happening?
- Is there an activistic idea we could all get behind?
- If we were going to make a mural together, where would we do it?
- If we were an art collective, what would we do?

IT TAKES A VILLAGE

GET OUT THERE—TOGETHER.

If you've got a group, and you're up for it, how about harnessing the forces of nature?

Next time you get together, you're not going to doodle; you are going to sculpt. We are going to embrace a little bit of the Bauhaus, but shift it a little.

The idea is that you are going to take a nature walk with your group. You'll suggest a place with plenty of trees, and you'll collect sticks and leaves and other natural items. Bring them back to base.

Looking back over your previous work, any collages, words, or ideas you've collected, perhaps you can suggest a theme to the group, a sort of big idea or guiding principle for what to turn these natural raw ingredients into.

As you work together, another good topic for discussion is the nature of collaboration itself. Can you compromise? Can you share? How do you put your idea of what should go where to one side? Is it truly the case that, when we come together, the sum of something is greater than its parts?

If you've made it this far and you're creating together, why not go back to the very start of this book and embark on the journey again as a group? By the end, I can only imagine what you'll all be doing!

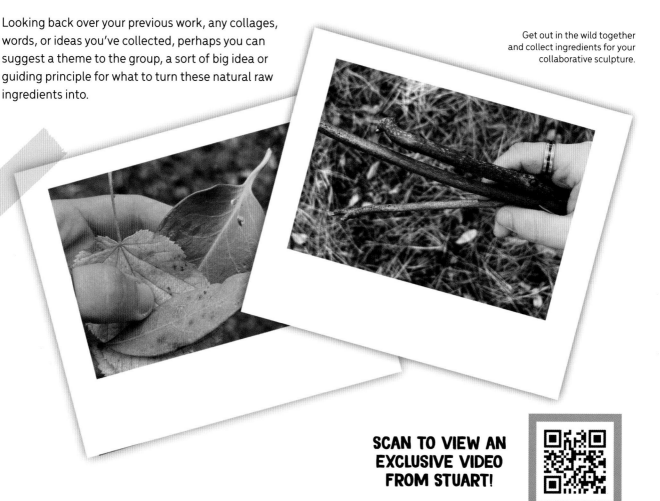

Get out in the wild together and collect ingredients for your collaborative sculpture.

SCAN TO VIEW AN EXCLUSIVE VIDEO FROM STUART!

Take your raw materials back to base and assemble them while discussing the nature of collaboration and compromise. By being together doing this, what are you learning?

Happily Ever After.

So, that's it, my friend. The stuff I've picked up along the way. I've done my best to share the best of it, and I hope, more than anything else that you have found a tiny little spark in here that ignited something in you. A spark that I hope you stoke from time to time and one you find the confidence to share with those around you.

I can't claim to know if we have one life or many, but I do know we are here now and that expressing ourselves is the way we find meaning and the way we connect with others. There's nothing more important that you can do. So, if you've started, promise yourself that you won't stop. It's as close to a "happily ever after" ending that I can give you.

I LOVE YOU,
Stuart x

RESOURCES

BOOKS.

Anderson, Simon. *In the Spirit of Fluxus.* Minneapolis, Minnesota: Walker Art Center, 1993.

Berger, John. *Ways of Seeing.* New York: Penguin Classics. 1972.

Debord, Guy. *Society of the Spectacle.* London: Rebel Press, 1994.

De Wachter, Ellen Mara. *Co-Art: Artists on Creative Collaboration.* London and New York: Phaidon Press, 2017.

Droste, Magdalena. *Bauhaus: Updated Edition.* Cologne: Taschen, 2022.

Godfrey, Tony. *Conceptual Art.* London and New York: Phaidon, 1997.

Kaprow, Allan. *Essays on Blurring Art and Life.* Oakland, California: University of California Press, 2003.

Muir, Gregor. *Lucky Kunst: The Rise and Fall of Young British Art.* London: Aurum Press Ltd., 2009.

Ono, Yoko. *Grapefruit: A Book of Instructions & Drawings.* New York: Simon & Schuster, 2000.

Rippon, Jo. *The Art of Protest: A Visual History of Dissent and Resistance.* Watertown, Massachusetts: Imagine, 2020.

Schwartz, Ben. *Unlicensed: Bootlegging as Creative Practice.* Amsterdam: Valiz, 2023.

Simpson, Paul. The Colour Code. London: Profile Books, 2021.

St. Clair, Kassia. *The Secret Lives of Colour.* London: John Murray, 2018.

Wood, Catherine. *Performance in Contemporary Art.* London: Tate Publishing, 2019.

MAGAZINES.

Art Review: artreview.com

Frieze: frieze.com

Spike Art Magazine: spikeartmagazine.com

I keep my reading matter in the toilet.

WEBSITES.

Artnet.com

Artplugged.co.uk

Hyperallergic.com

Random.org

TO CONNECT WITH STUART.

stuartsemple.com

Instagram, X: @stuartsemple

Facebook: MrStuartSemple

YouTube: @StuartSempleArt

STUART'S ART MATERIALS.

culturehustle.com

Instagram, Facebook: @culturehustle

TikTok: culture_hustle

To share your work with Stuart and other readers, use the hashtag #makeartordietrying

THANK YOU FOR HELPING ME

Making a book like this is a lot of work, so there are plenty of people I need to thank for bringing it to life.

First of all, Joy at Rockport Publishers, for having faith in this book and being patient with my newbie approach to writing something. I've learned so much from you.

Harry's illustrations have really brought the whole thing to life, and I can't thank him enough for all his hard work helping me get the images in my head out and onto the page.

Emily Baldwin collaborated with me on the layout and design—she did an amazing job, and I hope you all love her style as much as I do.

Heather over at Quarto, whose visual flair has made this thing look so hot.

I need to thank the crew in my studio for not only putting up with my creative moods whilst trying to make this thing but for putting up with me taking photos of them for the book.

I'd also like to thank Beth Pickens because, without Beth and her help, I'd probably have given up on doing this thing when it got hard.

Most of all I want to thank all of you for reading this book and supporting my work for enough years to make and learn enough to fill a book.

Photo of Stuart by Sarah Morris, 2015

WHO IS STUART SEMPLE?

After a near-death experience as a teenager, whilst studying fine art at the Yorkshire Sculpture Park, **Stuart Semple** dedicated his life to being an artist.

Although diverse in its presentation, his body of work orbits around a handful of recurring themes: anxiety, society, cultural history, technology, connection, community, and freedom, working across painting, sculpture, happenings, and online.

Semple has enjoyed fifteen solo exhibitions dedicated to his work in London, Milan, New York, Hong Kong, and Los Angeles. His works have also been featured in numerous solo and group exhibitions, fairs, and biennials, and at institutions including the Barbican, Institute of Contemporary Arts, London, The Goss-Michael Foundation, Denver Art Museum, and The Whitworth, amongst others.

He has created large-scale public projects for cities including Melbourne, Dublin, London, Moscow, Manchester, and Denver and presented performance pieces and happenings at Dulwich Picture Gallery, The Bentway in Toronto, Hong Kong Arts Centre, and Glastonbury Festival.

Semple is regularly featured across the media and has seen major features in *The Times*, *The Guardian*, *Modern Painters*, *Frieze*, *Wired*, *i-D*, the *BBC*, *Vogue*, and several others. His BBC Radio Four documentary, *Hostile Design*, was nominated for a Radio Academy Award in 2019.

As a writer, he contributed a monthly feature to *Art of England* magazine for more than five years and has written for *The Guardian*, *Spanish Vogue*, *Artlyst*, and *Huffington Post*.

Stuart by Ed Hill, 2023

A keen speaker on democracy, accessibility, and the power of art to transform mental health and the public realm, Semple has spoken at Frieze London, Oxford Union, The Southbank Centre, and the Institute of Contemporary Art.

Semple regularly curates exhibitions that explore society and has done so for galleries in London, Milan, and New York.

During the pandemic, Stuart Semple founded GIANT, the UK's largest artist-run gallery space outside London, in his hometown of Bournemouth.

INDEX

INDEX